IMAGES
of America

NAUVOO

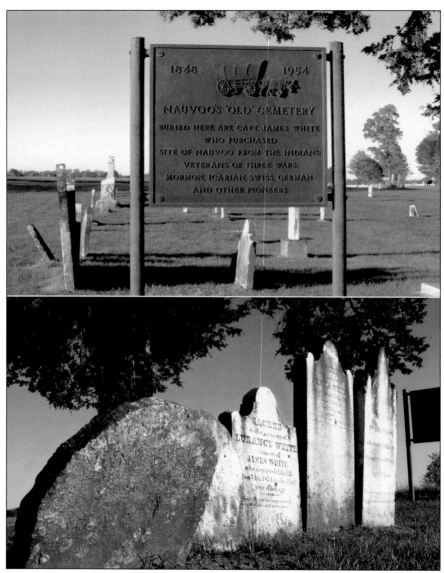

Capt. James White. Although the first known white settlers came here in 1803 (or 1801), it was Capt. James White who, in 1824, purchased land and became the first permanent settler. He named his settlement Venus. In a few years, it was expanded and became Commerce, then Nauvoo in 1840. Captain White and some of his family are buried in this Old Nauvoo Cemetery. (© 2006 photographs by Glenn Cuerden.)

On the cover: **Grape Industry in Nauvoo.** Grapes have played a major role in Nauvoo for one and a half centuries. The industry is celebrated in the annual Nauvoo Grape Festival, a regionally recognized, three-day event that has drawn large crowds since 1938. The Alois Rheinberger home is seen through Nauvoo's oldest vineyard, which Rheinberger planted in 1851. Located on the Flats in Nauvoo State Park, it was originally the 1840s home of Isaac Waggoner. Rheinberger purchased the site in 1850. Now a museum, it is open free to the public and operated by the Nauvoo Historical Society. (© 1975 photograph by Glenn Cuerden.)

IMAGES
of America

NAUVOO

Glenn Cuerden

Copyright © 2006 by Glenn Cuerden
ISBN 978-0-7385-4075-7

Published by Arcadia Publishing
Charleston, South Carolina

Printed in the United States of America

Library of Congress Catalog Card Number: 2006932963

For all general information contact Arcadia Publishing at:
Telephone 843-853-2070
Fax 843-853-0044
E-mail sales@arcadiapublishing.com
For customer service and orders:
Toll-Free 1-888-313-2665

Visit us on the Internet at www.arcadiapublishing.com

Contents

Acknowledgments		6
Introduction		7
Forewords		8
1.	Establishing the Mississippi River Frontier	9
2.	First Settlers in the Nauvoo Area	17
3.	The Mormon Era in Nauvoo	29
4.	German Immigrants Arrive between the Historic Eras	45
5.	The Icarian Era in Nauvoo	55
6.	Nauvoo Expands Again in the Mid-1800s	61
7.	The Midwest Is Quiet	83
8.	Wedding of the Wine and Cheese	101
9.	The Mormons Return	117
Bibliography		127

Acknowledgments

I started this historical overview when my mother left our 140-year-old family homestead near Nauvoo in 2000. She had lived in this same home for 62 years. This account is expanded from a booklet I produced in early 2004.

Much of my material has been gathered from old newspaper clippings, many of which no longer contain the date or the paper in which they were printed. I have researched scores of historical books, regional newspapers, old photographs, various Hancock County records, atlases, and my own family collection. Local individuals have provided photographs, and many images come from old postcards. I wish to thank Nauvoo citizens for their unselfish input and personal accounts. Credit goes to many local businesses, farmers, and neighbors, and to at least five past presidents and members of the Nauvoo Historical Society. Thanks to Kathy Burkett and the Hancock County Historical Society for allowing me to use history and images from some of their publications.

A very special thanks is extended to Nauvoo historian Ida Blum and Florence Bollin (both deceased) and to Marilyn Kraus, Leonard Hogan, Mary Lou and Jocko Fernetti, and especially to Mary Logan. Mary, who is a lifelong resident, fourth-generation Baxter, and a historian in her own right, has been of great assistance. She has been an ideal sounding board, providing much history, helping me track down elusive details, and proofing my material. Mary cannot receive enough praise. Thanks to other proofreaders, my wife Debby Cuerden and James Moffitt. I also appreciate the input from many local "old-timers" who have made this book truly a Nauvoo effort.

Many of the images depicted have been reproduced previously in a wide variety of places spanning a century and a half. It is almost impossible to determine their original source. Most photographs originated with local residents or were taken by the many regional newspapers and again reprinted through the ages as bits and fragments of Nauvoo's history. Where visual gaps existed I have supplemented this chronology with my own photographs.

Many newspaper articles, which provided much source material, contained misspellings, conflicting dates, and inaccurate information. All of the material required verification and additional research. To the best of my ability, I have attempted here to provide an accurate 200-year history of Nauvoo.

In memory of my parents and the many longtime residents of the Nauvoo area.

—Glenn Cuerden

Introduction

This is the 200-year history of Nauvoo and the early Mississippi River valley frontier. Nauvoo is a small community located inside a horseshoe-shaped curve of the Mississippi River in west-central Illinois. It is located 12 miles from the intersection of Illinois, Iowa, and Missouri. Enjoying a long and rich history, Nauvoo had its start at the wild and ruthless western border of the American frontier during the early 1800s, right at the Mississippi River's edge.

For many, many decades, Nauvoo has been known for its grape and wine industry, its grape festival, its Nauvoo Blue Cheese, and, more widely, as Joseph Smith's fast-expanding Mormon settlement before it was driven out of the area.

In 1824, Capt. James White purchased a frontier American Indian village called Quashquame from a Sac and Fox Indian tribe, and he named his small settlement Venus. The price, according to legend, was 200 bags of corn.

In 1839, the area was repurchased, developed by Joseph Smith and his Mormon followers, and then renamed Nauvoo. In 1846, the Mormons traveled westward to Salt Lake City, Utah, under the able leadership of Brigham Young. In 1849, the area was yet again repurchased and resettled as a French Icarian communal experiment lasting seven years.

As the Icarians vacated their settlement, it was populated from the mid-1850s by German and other hard-working immigrants.

Then, in the latter half of the 1900s, the Mormons gradually repurchased many of the properties. They rebuilt the temple in 2002.

Forewords

For those who study communal history, Nauvoo is perhaps the quintessential intentional community. From its humble beginnings as a Mississippi River town called Commerce to its rise as the Mormons' citadel on the prairie and the largest city in Illinois, and later as the capital of Icaria, the remarkable French commune founded by Etienne Cabet, Nauvoo's place is secure in the landscape of American studies. But Nauvoo's story is much larger than its utopian past. In this delightful book, photographer and writer Glenn Cuerden reveals a multifaceted community with a complex cultural heritage that belies its size and geography. Cuerden's graphic sensibilities and eye for photographic excellence contribute in no small way to the book's attractiveness and broad appeal, and his knowledge of western Illinois history illuminates every page. Arcadia Publishing's commitment to commissioning and publishing community histories such as Nauvoo cannot be overpraised. These efforts promote and preserve our collective past, broaden our appreciation of those who have come before us, and bring new audiences to the study of Illinois history.

<div align="right">

William Furry
Executive Director
Illinois State Historical Society
Springfield, Illinois

</div>

Glenn Cuerden, a veteran prize-winning photographer and writer, went to Nauvoo High School and returns in this book to his old stomping grounds. Glenn's fine photographs are merged here with 170 historic images. His crisp writing makes this a highly readable as well as a historically sound account of a national landmark. Glenn has collaborated with me on Colorado books and has provided photographs for many of them. Iowa Public Television (PBS) recently aired a feature that Glenn conceived, photographed, and wrote, titled *The Rural Midwest*.

<div align="right">

Prof. Thomas J. Noel
University of Colorado at Denver
Denver Post columnist

</div>

One

Establishing the Mississippi River Frontier

Both France and Britain strove to expand their territories and the fur trade in the New World. British colonies were established primarily between the Appalachian Mountains and the eastern seaboard. French settlements generally extended along the St. Lawrence River valley into the Great Lakes area. During the later 1600s, Frenchmen explored the upper Mississippi River valley. They gradually inhabited areas southward along this river during the 1700s. Most were fur traders, trappers, and river men, and they typically got along well with the American Indians. French trading posts were established along the Mississippi and its major tributaries.

A series of wars persisted between the two nations. During the last conflict, the French, assisted by American Indian tribes in the region, battled Britain for the territory during the 1754–1763 French and Indian War. The French eventually conceded defeat, and the 1763 Treaty of Paris gave France's territory east of the Mississippi River (as well as Canada) to Great Britain.

Prior to the 1800s, Woodland American Indians, including the Sac (Sauk) and Fox tribes, inhabited northern and western Illinois. From that combined tribe, Chiefs Keokuk, Quashquame, and Black Hawk were prominent participants in Nauvoo's early history. There were many other American Indian tribes in Illinois during one period or another. Most were descendants of aboriginal Algonquian-speaking tribes. Included were the Chippewa, Iliniwek, Kickapoo and Mascouten, Menominee, Miami, Ottawa, Potawatomi, Shawnee and Delaware, and Winnebago. (The Winnebago were probably the first inhabitants of the Hancock County area.) The tribes mostly roamed, hunted, fished, and warred with each other. Chief Black Hawk was one of the last holdouts in an unsuccessful effort to keep eastern settlers from encroaching on American Indian territory.

At the time of the 1803 Louisiana Purchase, a new culture was quickly emerging in the valley region. Aggressive pioneers cherished their newfound freedom on the frontier and gradually broke free from control by Great Britain. It would take only four more decades for America to push its boundaries all the way to the Pacific Ocean.

History has placed little emphasis on the development of America's heartland when compared with the ample attention devoted to the eastern seaboard and to the Wild West of the late 1800s. The famous town of Nauvoo proves to be a microcosm of pioneer settlement with its varied and fascinating history.

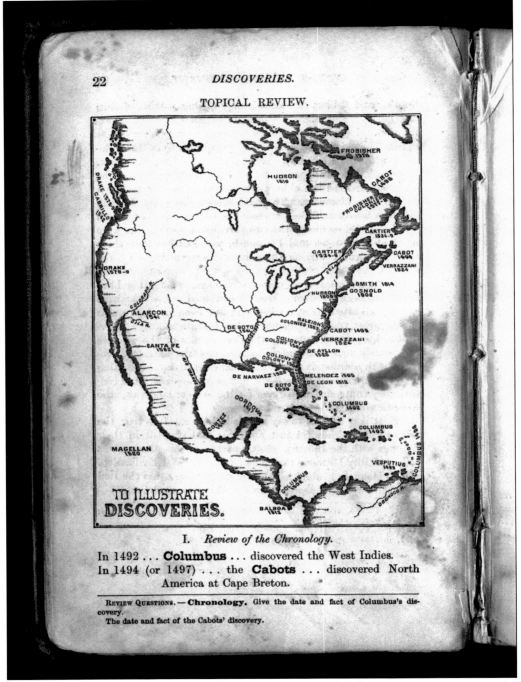

FROM 1513 TO 1579. Early explorations by Spain created a huge Spanish empire in the New World shortly after Christopher Columbus's discovery in 1492. Spain established a few settlements but eventually could not maintain these territorial claims because of costly wars on its own home front.

THE MISSISSIPPI RIVER, 1541. Spaniard Hernando de Soto had plans to conquer what later became Florida, enslave the natives, and quench his lust for gold. He trekked westward across the upper part of Florida and discovered the lower Mississippi River in May 1541. He pushed farther westward in his exploration, then returned a year later and died of a fever at the river's bank. He was buried in the mud at the bottom of the Mississippi in 1542.

MARQUETTE AND JOLIET. In 1673, seven French explorers journeyed down the Mississippi River as far south as the Arkansas River and canoed past the site of present Nauvoo. The party included mapmaker Louis Joliet, who charted the Mississippi, and Fr. Jacques Marquette, a Jesuit missionary hoping to convert the American Indians to Christianity. The French soon built a series of forts on the inland rivers with plans to dominate the interior and thereby limit Britain's access to only the eastern seaboard.

EXPLORING THE MISSISSIPPI, 1680. During a river journey, Frenchman René-Robert Cavelier de La Salle was accompanied by Henry de Tonty (the French military governor of the Illinois region) and a man named La Harpe. They were forced to abandon their damaged canoes at the head of a rapids on the Mississippi River. They came ashore at what is now Nauvoo before continuing their journey overland to Fort Crèvecoeur, now Peoria. In 1683, La Salle was again sent by his government to determine if the Mississippi River emptied into the gulf. It did. This discovery provided a great step forward in the exploration of the new country. La Salle claimed for France the St. Lawrence Valley, all land drained by the Mississippi, its tributaries, and the whole unknown interior of the continent.

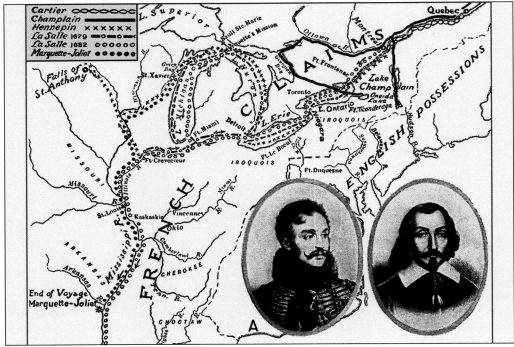

FUR TRADING. The Mississippi River afforded a route for convenient trading with American Indians, including the Sac and Fox tribes, which inhabited northern and western Illinois. Both the French and British established fur-trading posts on many of the rivers in the interior. This sketch depicts a French fur trapper in the Great Lakes region around 1700.

FRENCH AND INDIAN WAR. England eventually won the 1754–1763 war, and France did not contest England's claim to the lands. Per the 1763 Treaty of Paris, France agreed to withdraw its settlements from the New World while still retaining land in the West Indies and islands off the coast of Newfoundland.

13

BLACK HAWK. Black Hawk was born in 1767 in the main Sac village where the Mississippi and Rock Rivers meet, now Moline. The Sacs soon warred against, and subdued, the Osage tribe. His father, who was a Sac chief, was slain while attacking the Cherokees, and Black Hawk became a Sac tribal leader, some accounts say "Chief of the Sacs." This 1814 map is from a 1942 atlas.

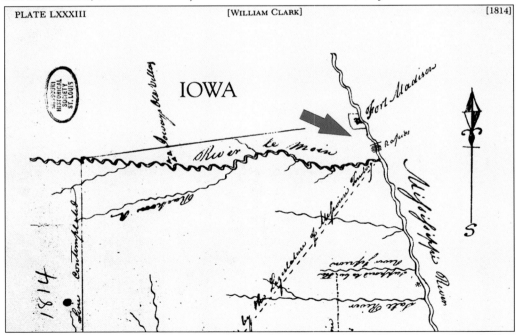

DES MOINES RAPIDS. This 1814 map depicts the River de Moin (Des Moines River), Fort Madison in Iowa, and the rapids immediately below. The settlement of Venus (Nauvoo) was later located at the head of this rapids in 1824.

EXPLORING THE WEST. Pres. Thomas Jefferson sent Lewis and Clark to explore the northern portion of this Louisiana Territory in 1803 (shown below) and to find a possible water route to the Pacific Ocean. They traveled up the Mississippi, reaching St. Louis in 1804 (165 miles south of Nauvoo), then journeyed westward on the Missouri River. Capt. Meriwether Lewis is shown at the top right, and his friend William Clark is pictured at the bottom. Clark was soon promoted to captain, equal in rank to Lewis.

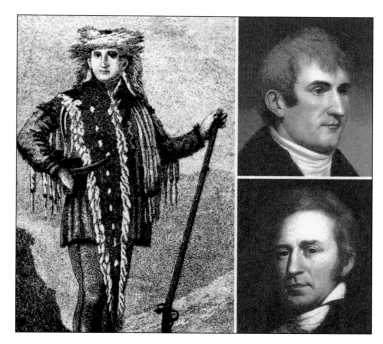

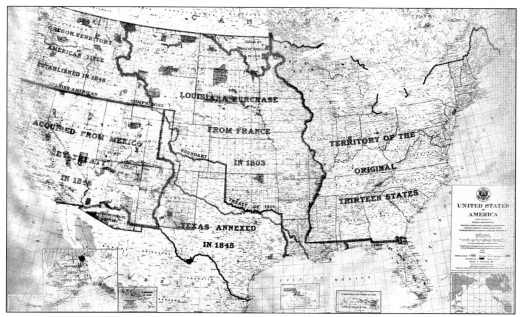

TERRITORIES OF UNITED STATES. President Jefferson successfully acquired the Louisiana Purchase from France in 1803 at a bargain price of $15 million. (Spain ceded that area back to France in 1801 but still claimed territory south of the Arkansas River and west of the Mississippi River.) There were very few settlers west of the Mississippi at this time.

MOVING THE AMERICAN INDIANS. In 1804, the federal government strove to move all American Indians into unclaimed territory west of the Mississippi River to avoid problems between them and the new settlers. A treaty was signed in 1804 between Indiana Territorial governor William Henry Harrison and five Sac and Fox chiefs. They included spokesman Chief Quashquame, who was friendly with the United States. He later sold land, which became Nauvoo, to Capt. James White. This treaty gave northern Illinois to the United States, which in return was to provide trading posts, education, and small annuities to the American Indians. This so-called treaty was disputed by Chief Black Hawk and others who asserted that the five chiefs had no authority to act for the entire American Indian nation. This typical land deed (pictured) signed by Pres. James Monroe in 1822 authorized a purchase by one of Nauvoo's first settlers. (© 2002 photograph by Glenn Cuerden.)

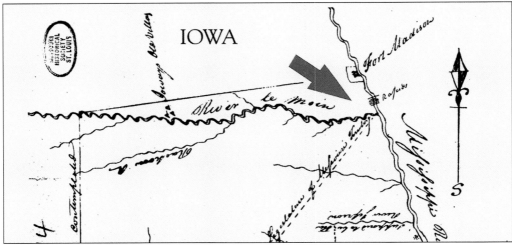

HALF-BREED TRACT. As part of a 1824 treaty, a 119,000-square-mile strip of land on the Iowa side of the Mississippi River was nicknamed "Half-breed Tract." It was roughly adjacent to the Des Moines Rapids and extended south (including present-day Keokuk, Iowa) to the Des Moines River (River de Moin). It was set aside by the federal government for the offspring of mixed marriages between frontiersmen and Americans Indians but did not meet with much success. Most American Indians and frontiersmen were not content to settle in one place as farmers. Land speculators also took advantage, deeds were obscure, and the same plots of land were often sold to more than one buyer on this lawless frontier. This 1814 map is part of a 1942 atlas showing American Indian villages of the Illinois Country and was compiled by the State of Illinois.

Two

First Settlers in the Nauvoo Area

The western frontier of the United States in the early 1800s was centered around the Mississippi River valley. It was a frontier of rugged individualism. Early frontier pioneers encountered cholera, dysentery, typhoid, malaria, black diphtheria, and a myriad of hardships as the first homesteads were carved out of the wilderness. The 1804 treaty, which Chief Black Hawk refuted, aimed to eventually remove the Sac and Fox tribes. A series of treaties with the American Indians put the territory (now Illinois) into the hands of the government. After the War of 1812 with Britain, the federal government made a concerted effort to move American Indians west of the Mississippi River into unclaimed territory. The government had its eye on expansion and wished to avoid conflict between the settlers and the American Indians.

A surveyor's cabin was built here, later Nauvoo, on the eastern bank of a horseshoe bend in the Mississippi River. It was built by the federal government in 1803 for American Indian agent William Ewing. (Some accounts put the date at 1805, others at 1801. There is also some indication of an earlier Spanish land grant, and perhaps a few Spanish did come here earlier than 1803. There is very little research regarding this area, which hosted Americans Indians, Spanish, French, British, and then Americans during various eras.)

Capt. James White became the first permanent white settler in Nauvoo, probably arriving in late 1823 or early 1824. He purchased the site of a Sac village (of 400 lodges per one account) named Quashquame (or Jumping Fish) from its leader by the same name. Quashquame relocated his band to the western bank of the Mississippi. Captain White soon named his settlement Venus. John Waggoner and Davison Hibbard arrived soon after and settled approximately six miles south of White in what later became Montbello Township. A few settlers gradually built crude log cabins that dotted the riverbank approximately every mile. In 1833, the adjoining area (later designated as Hancock County) had a total of only two towns or villages, Venus (Nauvoo) and Fort Edwards. By 1843, the river towns in Hancock County (north to south) were listed as Pontoosuc, Appanoose, Nauvoo, Des Moines City, Monte Bello, Warsaw, and Warren.

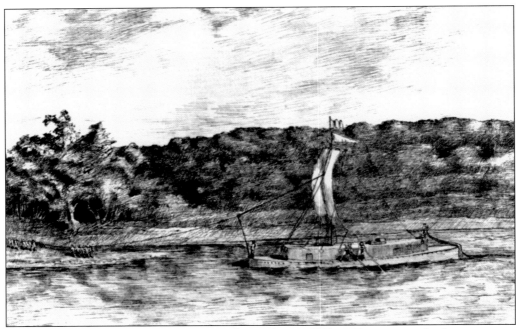

THE FIRST SETTLERS. In June 1803, Pennsylvania farmer William Ewing arrived at his temporary post on the site of present Nauvoo to conduct a government agricultural experiment and to teach the American Indians husbandry. He may have visited the location even earlier, as some accounts indicate. Ewing was accompanied by his Creole interpreter, Louis Tesson Honoré. A 1819 land deed indicates that a Dennis Julian (Julien) also settled on 640 acres a few miles south of William Ewing's governmental project in 1805. Julian may actually be the area's first permanent settler. Early keelboats were powered by the current, paddles, poles, towlines, and even by the wind or whatever means worked best.

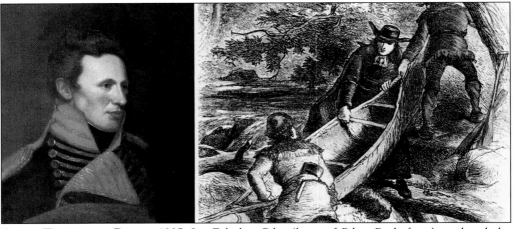

EARLY TRAVELERS. During 1805, Lt. Zebulon Pike (later of Pikes Peak fame) explored the southern portion of the Louisiana Purchase and the upper Mississippi River. In August, he traveled north through the dangerous Des Moines Rapids located across from where Nauvoo now stands. He was assisted by William Ewing, Louis Tesson Honoré, and American Indian guides and stayed overnight in the Ewing cabin. Illustrated here is an earlier exploration where Pike is accompanied by a missionary and guides.

WAR OF 1812. The colonies again declared war against Britain due to high taxation and a limitation on commerce. Pictured is the *Constitution* destroying the British frigate *Guerriere* off the St. Lawrence waterway. Colonists feared that the British might try to gain control of the Mississippi River valley, and Zebulon Pike planned the construction of Fort Johnson. It was built September 1814, on a bluff located across from the mouth of the Des Moines River at what is now Warsaw, about 15 miles downriver from Nauvoo. The short-lived fort was commanded by Brevet Maj. Zachary Taylor. They burned their own fort later in the year, and Major Taylor returned to St. Louis to command all American forces in the Missouri Territory. Part of the Sac and Fox Indians were sympathetic to the American cause, but Black Hawk, Sac chief of the Thunder clan, fought bitterly on the side of the British. They lost the war.

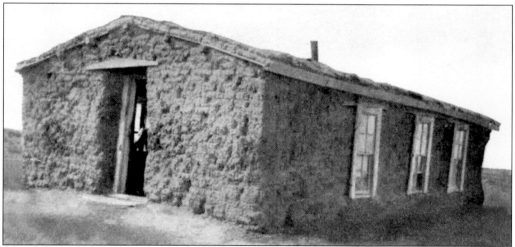

AN 1814 TREATY. The United States signed a peace treaty with Great Britain ending the War of 1812 and could now concentrate on westward expansion. War veterans were awarded frontier lands as severance pay, per their rank. A private could receive 40 acres and a team of mules free if he met certain requirements, such as clearing part of the land and living on it for a period of time. Certain ranks could receive 160 acres and a team of horses. A few early pioneers settled on prairie land east of the Mississippi where there were tall prairie grasses and limited timber. Some built serviceable sod homes with dirt floors like the one pictured.

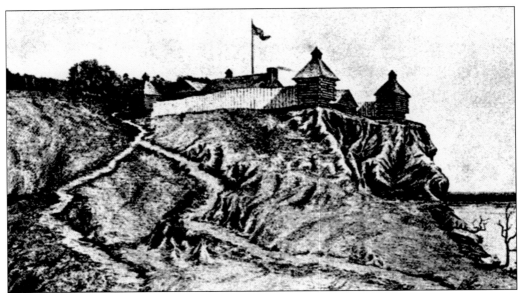

FORT EDWARDS, 1815–1824. A detachment of infantry ascended the Mississippi River in keelboats, initially planning to establish a fort at Rock Island for control of American Indians after the Black Hawk War. In November, they became stranded by ice at the mouth of the Des Moines River near the former Fort Johnson site. They wintered there, renaming it Cantonment Davis, and later built Fort Edwards (above) to protect the area from the Potawatomi Indian tribe. Later the fort was used as a fur-trading post, trading with the friendly American Indians. Fort Edwards was vacated in 1824.

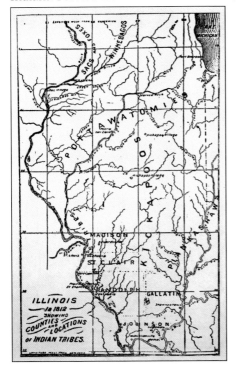

AUGUST 26, 1818. Illinois became the 21st state of the Union. Kaskaskia was named the state capital and not Springfield. This map depicts Illinois as it appeared previously in 1812.

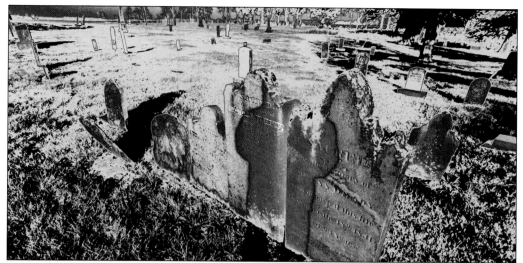

VENUS SETTLEMENT. Capt. James White arrived in the area (now Nauvoo) in early 1824. He purchased land from the Sac Indians, an encampment of perhaps 400 lodges named Quashquame. Local legend maintains the purchase price was 200 sacks of corn. (Some accounts claim it was cornmeal.) The American Indians had camps on both sides of the river, and they permanently relocated across the river at present-day Montrose in untamed Iowa Territory. White named his settlement Venus and first moved onto what may have been the old 1805 Dennis Julian site or William Ewing's 1803 cabin. White's grave is now located in the Old Nauvoo Cemetery. His tombstone is pictured above. (© 2003 photograph by Glenn Cuerden.)

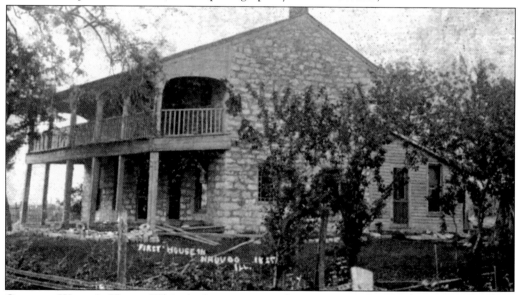

CAPTAIN WHITE'S HOME. White built a permanent home near a spring at the river's edge (now Parley Street). His neighbor, John Waggoner, did the masonry. It was the first stone building in the county, and the Venus post office was located here. The area was known as the Adams District, and when big enough, it was renamed Hancock County. The first county court was held in White's house. When the Keokuk Dam was completed downriver in 1913, the water level rose 25–30 feet at Nauvoo, partially submerging White's house, which gradually deteriorated and was torn down around 1928.

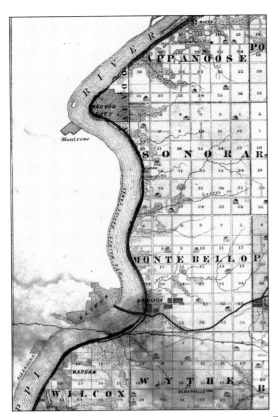

MONTBELLO TOWNSHIP, 1824. John Waggoner became the first white settler in Montbello Township, located south of Capt. James White. A daughter of Montbello's second settler, Davison Hibbard, married one of Captain White's sons, and the wedding was attended by friends Chiefs Black Hawk and Keokuk. This 1874 atlas map locates the Des Moines Rapids Canal, built after 1848 to afford a safer journey up and down the Mississippi River.

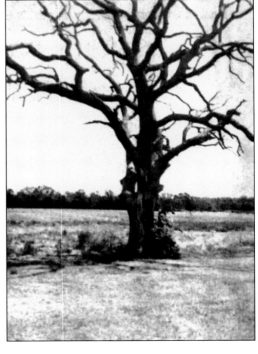

TRADING OAK. A local legend maintains that Captain White negotiated the purchase of Venus from American Indian chief Quashquame under this large burr oak, known locally as the Trading Oak. It was adjacent to the Captain White home, near the river's edge.

EARLY SETTLERS. In 1827, John Moffitt built his log cabin overlooking the river. It was two miles south of Nauvoo and north of Sheridan Creek. The Moffitt extended families soon carved out additional, adjacent homesteads. This split-log portion of Moffitt's original cabin exists to the present day. It is the oldest continuously family-owned structure in the Nauvoo area. (© 2002 photograph by Glenn Cuerden.)

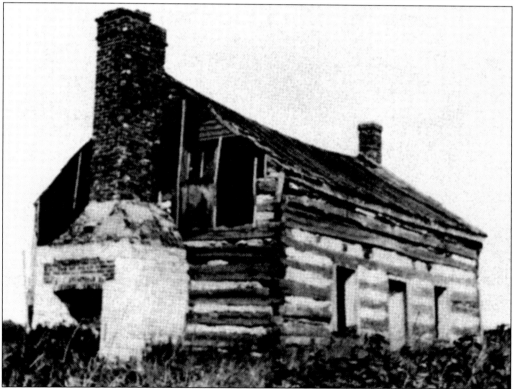

EARLY HOMESTEADERS. Many of the homes are similar to this 1838 Hancock County structure. (Courtesy the Hancock County Historical Society.)

SAC AND FOX INDIANS. The Sac and Fox tribes inhabited the area after driving the Iliniwek from northern Illinois. They wore moccasins, leggings, and breechcloths. Their canoes were dug out or made of birch bark. They hunted and fished. Buffalo, deer, and turkeys were plentiful in the area. There were fruit, nuts, beans, squash, pumpkins, and wild rice. Wild grapes, gooseberries, and plums flourished. The untilled, flat prairie land lying west of the river consisted of very tall prairie grasses divided by small creeks.

THE SETTLEMENT OF VENUS. Capt. James White's village became official in 1830 with its own post office located in his home. White's known occupations were surveying, keelboat operating, and farming. By this time, there were a few scattered homesteads and trails along the river's edge. Travel was by water, horseback, or by "shanks' mare" (on foot). (© 2000 photograph by Glenn Cuerden.)

THE BLACK HAWK WAR. As early as 1804, government agents initiated removal of the Sacs and Foxes to the west side of the Mississippi. Chief Keokuk moved peacefully. Black Hawk (Ma-ka-tai-me-she-kia-kiah) refused to give up his village at Rock Island, where it had thrived for about 65 years. This principal Sac village contained approximately 60 lodges at its height. The government disregarded its 1804 American Indian treaty and began to sell parcels of land there as white settlers continued to move onto the land. They built fences, tore up cornfields, and even destroyed some American Indian lodges. These settlers were finally attacked by Black Hawk, pictured at right. The Black Hawk War did not reach as far south as Venus, which got along well with the tribe. Greatly outnumbered, the American Indians were defeated at the Battle of Bad Axe in 1832. About 300 were shot. As pictured below, they attempted to retreat along the bank of the Mississippi.

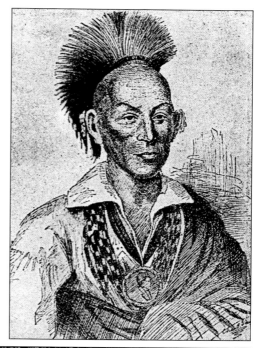

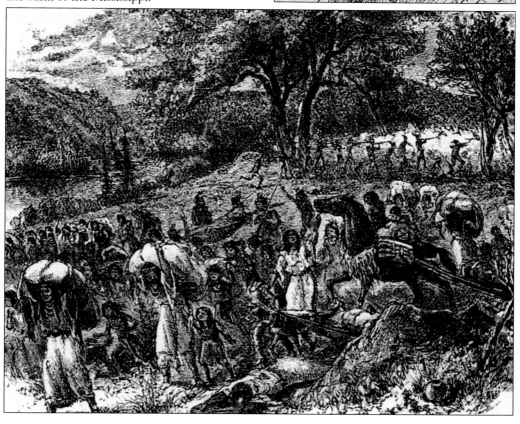

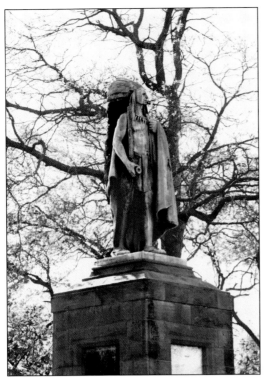

CHIEF KEOKUK. After the Black Hawk War, Sac chief Keokuk was made leader of the Sac and Fox bands by the victor, the U.S. government. Earlier Keokuk had peacefully relocated to the foot of the Des Moines Rapids (now Keokuk, Iowa), 12 miles below the Venus settlement. He cooperated with the government and had a close friendship with white settlers in the area. He was also very fond of alcohol. Chief Keokuk, also known as the Watchful Fox, was born during the late 1700s in north-central Illinois, and he died in 1848, in Kansas. He was buried at this monument site in Keokuk's Rand Park, his statue overlooking the Mississippi. This 1834 illustration (below) by George Catlin depicts Chief Keokuk in his later years. (Top, © 2006 photograph by Glenn Cuerden.)

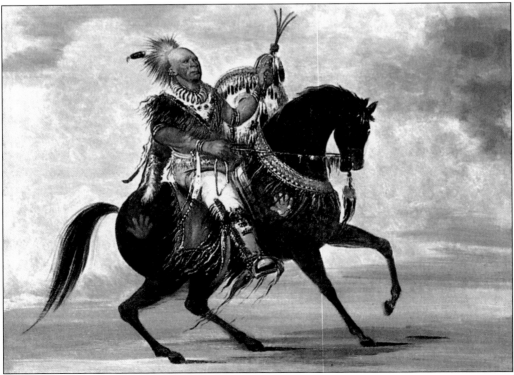

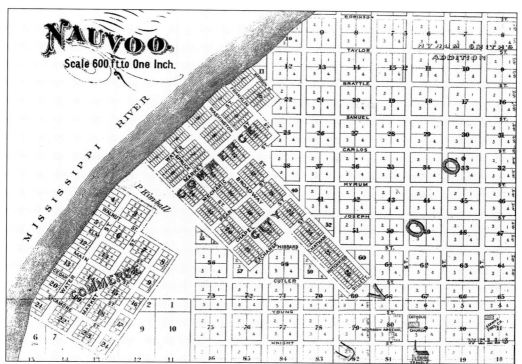

VENUS EXPANDS SOMEWHAT. On October 11, 1834, Venus was plotted by Joseph B. Teas and Capt. James White's son Alexander and was renamed Commerce. About this time, Father Lefevre, a Catholic priest, arrived via the Mississippi River and served as a missionary for the area. In 1837, the town was again replotted as Commerce City, slightly to the north, by land speculators. However, it was a paper-plotted town. There was a national financial panic in 1837, and the town failed to grow much before purchased by the Mormons in 1839. At the time of the purchase, the town was still called Commerce by most accounts.

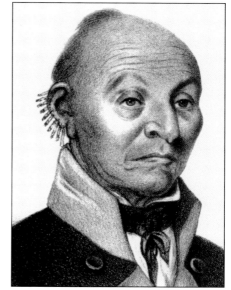

CHIEF BLACK HAWK DIES. On October 3, 1838, the great chief left his favorite hunting ground near the Des Moines and Skunk Rivers for an eternal one. Chief Black Hawk was 71. His remains were eventually taken to Burlington, Iowa, but were lost in an 1855 fire when the Burlington museum burned.

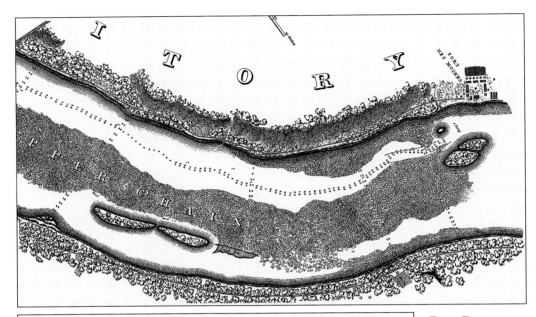

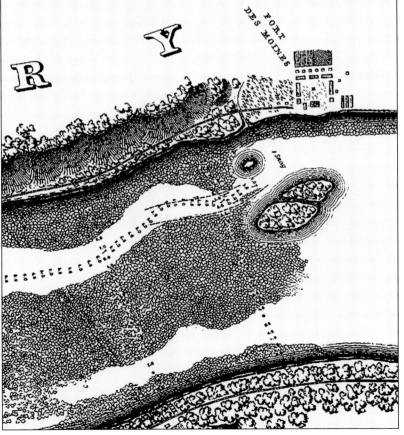

FORT DES MOINES, 1837. Before the Civil War, a young Robert E. Lee, surveyor for the U.S. Army, made two trips to chart the Mississippi River for a canal to tame the rapids. Fort Des Moines (now Montrose, Iowa) was located at the head of this rapids. It was the last fort built in the territory of the former Ioway (or Le Moin, or De Moyen) Indian band.

Three

THE MORMON ERA IN NAUVOO

Governor Boggs of Missouri issued an extermination order in early 1839, demanding that the Mormons vacate his state. The Mormons, whose primary settlements were in Missouri at this time, bought land at Commerce. Under Joseph Smith's leadership, they relocated here and renamed it Nauvoo, which is said to mean "beautiful place" in Hebrew (although no direct translation has ever been determined). Soon the town accomplished amazing achievements in growth and organization, and it became the largest city in Illinois. It also exerted an unprecedented and expanding control over the region. This seven-year settlement of the Latter-day Saints soon created local strife and violence, as viewpoints clashed.

On the frontier, 1839 was a very rugged time. Nauvoo's explosive expansion was accompanied by the theft of local crops and property, sometimes even the daughters or wives of neighboring settlers. Many Mormon converts who arrived were expecting a utopia and found that conditions were not what they expected. Many newcomers were without anything to their name. Nauvoo also attracted lawless criminals who hid in the city under the guise of being Mormon, without fear of prosecution due to the protective laws and policies of the Nauvoo township.

Illinois had just become a state in 1818. Although Continental laws were enforced to the best of the nation's ability, much was still determined by the collective values of each particular frontier region. This period before the Civil War still reflected various ideals about what principles should govern a new democracy. Also, many settlers were closely tied to the early American colonists whose values created this democracy. They fought a war to escape the tyrannical and imperial government of King George III, so Joseph Smith's autocratic and theocratic form of government was in conflict with many of the values of established settlers. Many non-Mormons were also afraid of Joseph Smith's power and methods.

The destruction of the *Expositor* newspaper by disenchanted and disenfranchised Mormons in June 1844 became the spark that initiated the final outcome of an already bitter conflict. Joseph, his brother Hyrum, and others were charged and taken to the county jail in Carthage. Illinois governor Thomas Ford was appalled at the lawlessness and arrived with a hastily assembled militia, but he was helpless, or reluctant, to quell the problem. He was not able to prevent Joseph and others from being killed. By now each side, Mormons and a large group of anti-Mormons, was bitterly entrenched. Governor Ford determined that the enforcement of established governmental law had become impossible. He realized there was no possibility for a permanent truce and eventually agreed with many that the only long-term solution was for the Mormons to leave the area.

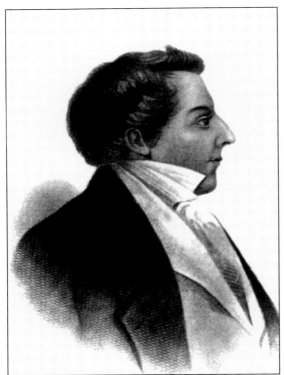

A NEW HOME, 1839. Missouri was presently holding Joseph Smith (pictured) in jail at Liberty for counterfeiting and other charges. Missouri's Governor Boggs had issued an order for all Mormons to vacate the state. Land speculator Isaac Galland, wishing to sell his marshy holdings in Commerce and professing to be strongly religious, contacted the Mormon leadership located downriver in Quincy. Smith sent an advanced group to the Commerce area seeking a new location for his Missouri settlements, wishing to escape his escalating problems there. On the recommendation of Smith, Sidney Rigdon, Mormon spokesman and chief apostle of the Latter-day Saints, purchased the White and Galland farms at Commerce. The Mormons renamed the area Nauvoo. Capt. James White's home, which Galland obtained four years earlier, was included in the sale. Sidney Rigdon moved into that structure in April 1839.

THE WHITE PROPERTY. When purchased by the Mormons, this area was wet and marshy in places, tangled with bushes and trees, and difficult to penetrate even by foot. The area contained approximately 10 houses and various outbuildings. This image shows how the site appears today, basically a lowland wooded area beside the river. (© 2004 photograph by Glenn Cuerden.)

MORMONS ARRIVE FROM EUROPE. Joseph Smith relocated his followers from previous Missouri settlements. Nauvoo soon became a religious haven for Mormons as many recruits were gathered by missionaries from the eastern states, from Canada, and especially from the British Isles. Many immigrants were escaping political, economic, military, and religious problems in their own countries and were seeking a new start in Nauvoo. Many traveled up the Mississippi from the Gulf of Mexico (pictured below).

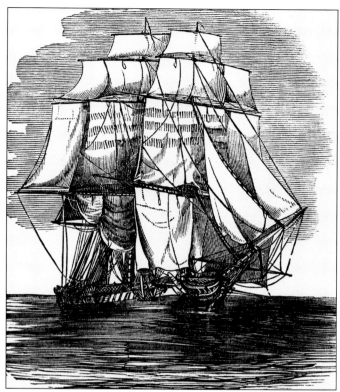

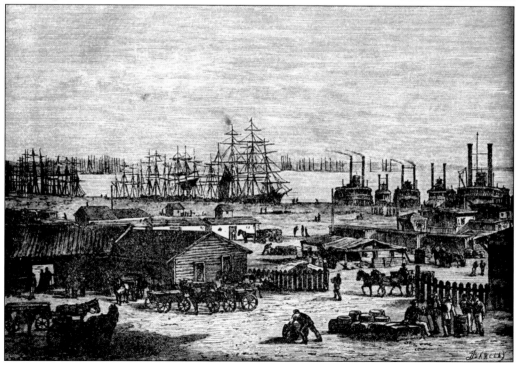

ISAAC GALLAND. Isaac Galland was considered unscrupulous in Illinois by many locals. In 1839, however, Galland was able to sell the Mormons a 20,000-acre tract at $2 per acre, with 20 annual payments and no interest. This was a good price, although it was land he did not own. Located just above the Des Moines River in Iowa Territory, it was a part of the Half-breed Tract mentioned earlier. The deed proved to be bogus, and eventually the Mormon families who settled there lost the property and moved across the river to join the Nauvoo settlement.

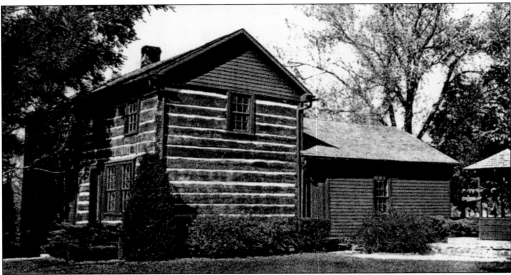

JOSEPH SMITH'S HOME. Pictured on this c. 1920 postcard, the Joseph Smith home was owned and restored in 1918 by the Reorganized Church of Jesus Christ of Latter Day Saints (RLDS). The original log cabin portion (identified in the center of this photograph) may have been William Ewing's early cabin. The structure was repurchased in 1839 for Joseph Smith and subsequently remodeled. A wing was added in 1840, and it was here that Smith conducted much of his business as leader of the Mormon Church. It became a center of constant activity as Smith welcomed a steady flow of followers and out-of-town guests.

SMITH HOME BEFORE RESTORATION. This is how the home appeared in an early-1900s postcard, before restoration. It remained the property of the RLDS. Smith also operated a general store near his home called the Red Brick Store. Its second floor contained his small office plus a large room used for council meetings and other purposes.

NAUVOO MANSION HOUSE. Joseph Smith's second home, pictured here in the 1900s, was built for him by his followers. He lived here 1843–1844, across the street from his original residence, which was becoming overcrowded. This new home functioned as an official statehouse for conferring with dignitaries and provided housing for his frequent visitors.

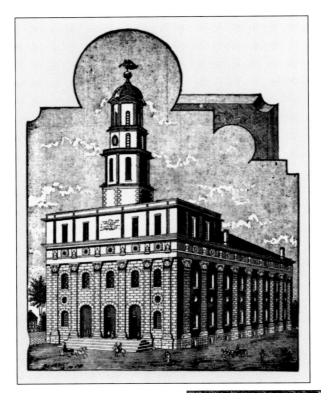

THE TEMPLE. The cornerstone for the Nauvoo Temple was laid on April 6, 1841, on the 11th anniversary of the 1830 founding of the Mormon Church by Joseph Smith in Palmyra, New York. Limestone blocks were quarried locally, and lumber was rafted downriver from Wisconsin. Construction was accelerated after Joseph Smith's death, and the temple was dedicated and used. It became a major landmark but was not completed when the Mormons left in 1846. The total cost was estimated at $1 million. This sun stone, below, from the original temple has remained in Nauvoo. (Below, © 1975 photograph by Glenn Cuerden.)

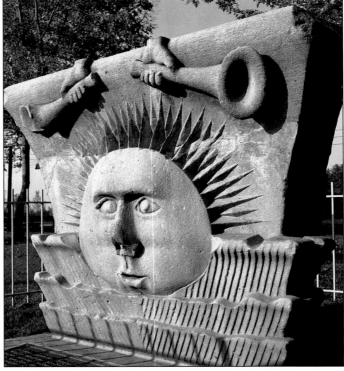

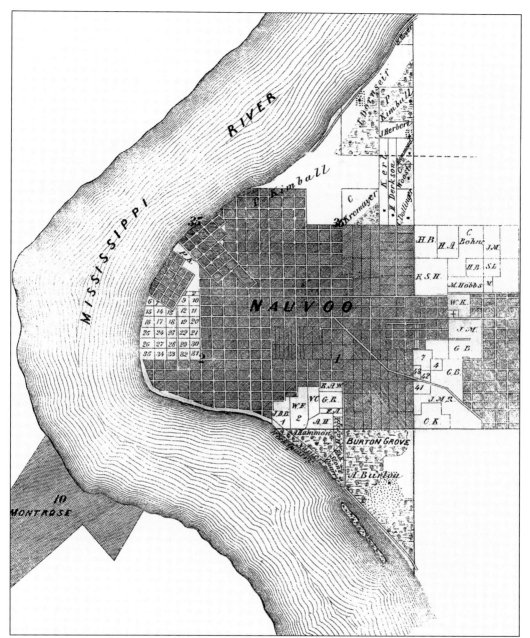

NAUVOO GROWS. Nauvoo became an impressive town of approximately 11,000 to 12,000 Mormons, probably larger than Chicago for a short period of time. An 1845 Illinois census lists 11,057. Not surprisingly, there was maneuvering for political power and dominance in Illinois during these early decades of statehood. Joseph Smith assumed a role. With his charisma and a large voting block, Smith initially gained the favor of both the Whigs and the Democrats. He played a part in Illinois politics and later helped Democrat Stephen Douglas defeat Republican Abraham Lincoln in Douglas's reelection bid for the state senate.

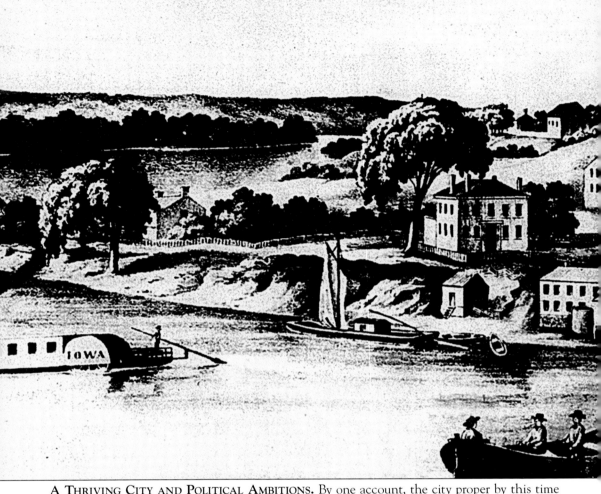

A THRIVING CITY AND POLITICAL AMBITIONS. By one account, the city proper by this time extended 11 blocks north, south, east, and west of the temple. There were four boat landings. Joseph Smith was gaining in political power and had aspirations of becoming president of the United States. He announced his Independent Party candidacy in February 1844 with Sidney

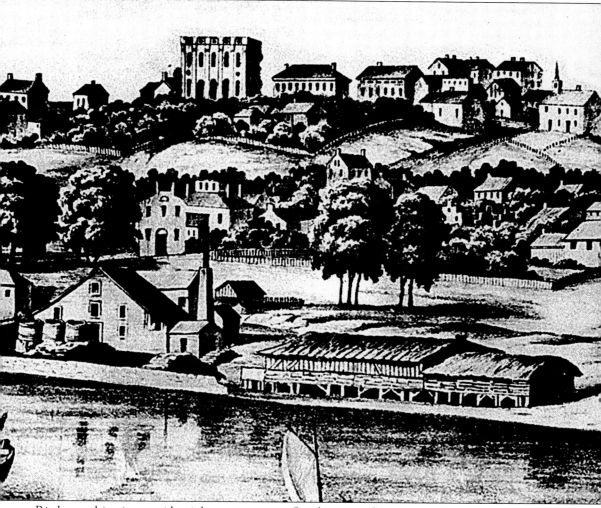

Rigdon as his vice presidential running mate. Smith initiated a nationwide campaign effort, but by now, his problems had reached a critical mass. This sketch of Nauvoo by John Schraeder appeared on an 1859 map of Hancock County.

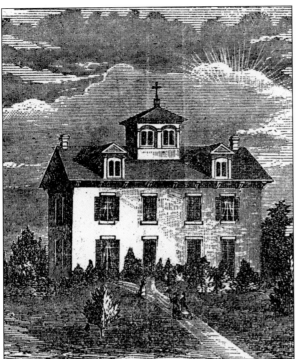

FORMATION OF THE NAUVOO LEGION, 1841. Joseph Smith took advantage of a loophole in Illinois law and convinced Illinois's Governor Carlin to sign a Nauvoo charter allowing the Mormons to develop an independent armed militia, the Nauvoo Legion. This action was not viewed favorably by surrounding towns or by local settlers who felt threatened. By 1844, this militia grew to 1,800, or 3,000, or 5,000 men. Historical accounts of the size vary greatly. Smith's army became even larger than the Illinois State Militia and was surpassed only by that of the U.S. government. Smith had firm control of the Mormon Church, its followers, its finances, the Nauvoo City Council, and the city's court system. He was appointed lieutenant general of his Nauvoo Legion militia and was gaining political power in the county. Therein lay much of the conflict already developing. The Mormon Arsenal is pictured here.

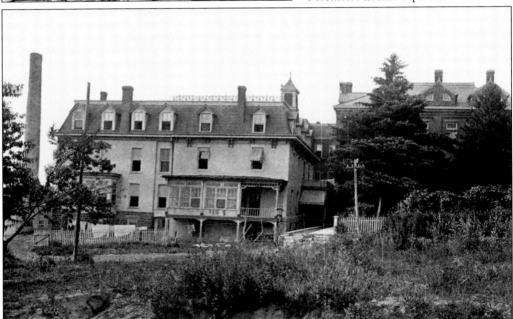

FORMER MORMON ARSENAL. Shown here in the early 1900s, the arsenal at this time was part of a complex owned by the Benedictine Sisters. The expanded arsenal building served as housing for a girls' school, the St. Mary's Academy. Then, amid controversy that it should be kept as a historic landmark, it was torn down in 1966 to make room for a 1967 expansion of the academy.

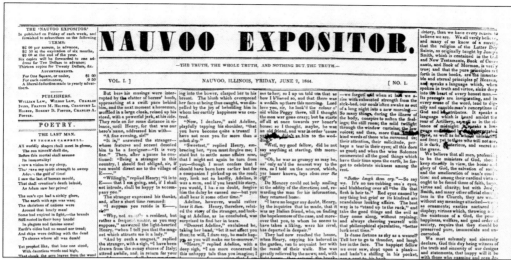

SUMMER 1844. A group of disenchanted and disenfranchised former Mormons started their own newspaper, the *Expositor*. It included William and Wilson Law, Robert D. Foster, Francis Higbee, John C. Bennett (the first Mormon mayor of Nauvoo), and others. They wished to reform the religion, and they disagreed with some of Joseph Smith's actions, condemning his authorization and practice of polygamy and other policies.

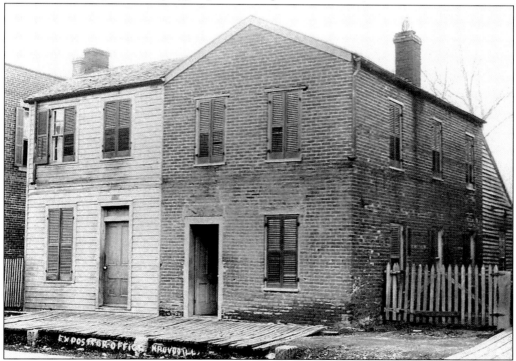

THE *EXPOSITOR*. Only one issue of this newspaper was published, June 10, 1844, in the lower floor of this Nauvoo brick building. Joseph Smith immediately convened the Mormon City Council, which ordered the newspaper to be destroyed. It was. This event triggered widespread reaction, lawsuits, and an appeal to Illinois governor Thomas Ford for his immediate involvement.

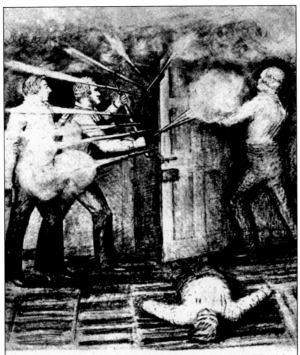

No. 31H. MOB FORCING THE JAIL AT CARTHAGE, ILL., JUNE 27th, 1844.

In this picture, Joseph Smith is seen holding an old "pepperbox pistol, three chambers of which he discharged at the mob as the warmed up the stairs. Hyrum Smith was the first victim of th ssassin's bullet, being killed instantly at the first volley through th oor. John Taylor, who is seen beating against the mob with a cane ll seriously wounded next, and Joseph Smith was pierced by tw ullets as he attempted to leap from a window. He fell to th round, and was murdered as he leaned against a well curb in th il yard. Willard Richards, seen endeavoring to close the doo caped unharmed.

BACKLASH, 1844. The June destruction of the newspaper lit the fuse of outrage. Joseph Smith and his brother, Hyrum, John Taylor, and other key council members were taken to the Hancock County jail in Carthage and held for trial. Gov. Thomas Ford did arrive, but he proved unable to prevent the eventual outcome. While in jail, Joseph and Hyrum were shot on June 27 by an anti-Mormon group that had grown violently opposed to Joseph Smith's actions. The incident was often referred to as a mob action, but a more apt description would be a planned assassination by an anti-Mormon group of about 100 that masterminded a large-scale attack. Some participants were prominent longtime residents of the area, some having previous business conflicts with Joseph Smith. A county trial was later conducted, but no one was actually convicted. This early drawing (dramatically) depicts the shooting, which transpired on the jail's second floor. Hyrum lies dead. John Taylor is wounded. Joseph Smith, who obtained a smuggled pistol, wounds three of the attackers before he is shot and killed.

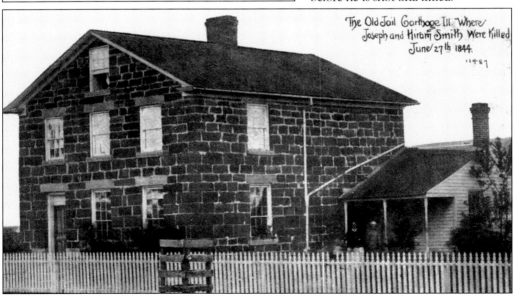

The Old Jail Carthage Ill. Where Joseph and Hiram Smith Were Killed June 27th 1844.

THOMAS SHARP. Growing pressure was exerted by surrounding towns for all Mormons to leave the area. Both sides of the conflict persisted in violence, causing a few deaths. Thomas Sharp was a key figure in the anti-Mormon movement. A continually influential agitator, he was the outspoken editor of his *Warsaw Signal* newspaper. In 1840, Sharp moved to Warsaw from the east by way of Quincy, where he practiced law for a short time. Politically oriented and extremely strong in his beliefs, he purchased and renamed the local Warsaw newspaper. Sharp was one of several prominent men implicated, and apparently involved, in the murder of Joseph Smith. After lengthy maneuvering and a complex trial, no one was ever convicted. Later in life, Sharp became a justice of the peace and a county judge. (Courtesy Hancock County's *History of Hancock County, Illinois*.)

STRUGGLE FOR LEADERSHIP. The church again found itself mired in a crisis. Smith's death necessitated the quick return of Mormon leaders who were occupied in the East campaigning in his presidential bid. Thomas Sharp, through his newspaper, the *Warsaw Signal*, and anti-Mormons elsewhere, accelerated a campaign exerting pressure on the Mormons while a number of separate groups vied for leadership and control within the church. Some of the conflicting issues revolved around polygamy. A few members of the 12 apostles within the church's main leadership emphatically opposed Brigham Young. However, Young soon wrested leadership from Sidney Rigdon as the church splintered into factions.

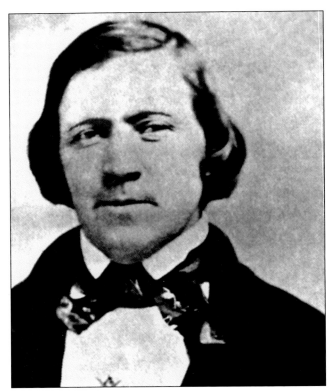

BRIGHAM YOUNG. The Mormons agreed to leave Hancock County, and they made extensive preparations. On February 4, 1846, Brigham Young led his first group of discouraged Mormon settlers across the frozen Mississippi River in the dead of winter. They crossed into Iowa Territory. Some camped there for the remainder of the winter, as pictured in the scene below. Some immediately trekked westward via the later-named Mormon Trail to find a new home. All eventually settled in what is now Salt Lake City, Utah.

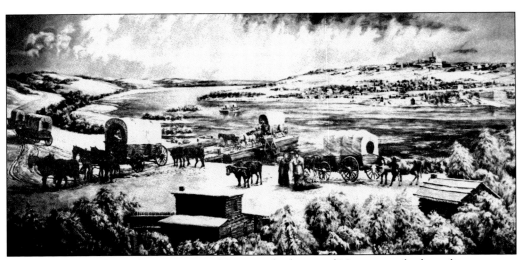

EXODUS OF 1846. By midsummer, most Mormons had vacated Nauvoo, and a few splinter groups attempted settlements elsewhere. The RLDS was the most prominent example. (Now named the Community of Christ Church, it is headquartered in Independence, Missouri.)

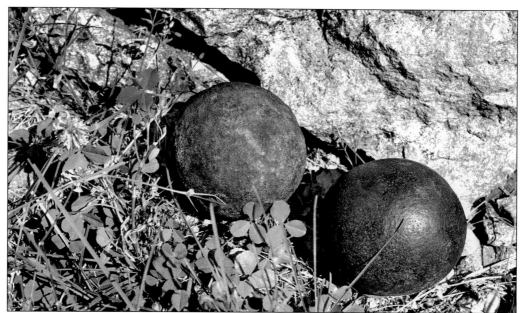

THE MORMON WAR. A September campaign was mounted to remove all remaining Mormons from the area. The defenders in this three-day, so-called "war" were those who had stayed behind after the exodus. A few non-Mormons had started to settle in Nauvoo, purchasing Mormon homes for very little money, and most were not interested in becoming involved in the conflict. Three days of skirmishes took place on the northeast edge of Nauvoo's township boundary. A party of 800, commanded by Tom Brockman, advanced on the city from the east against 300 defenders under Capt. Andrew Lamoreaux. A brave (Mormon) Captain Anderson, with a small group of men, led the counterattack. He and his son were killed, and there were a few causalities on each side. The battle ended September 16, and a treaty was signed the next day. The war was over, and the militia took charge of the town. These cannon balls are from the Mormon War, and this wooded area is the scene of the 1846 battle depicted at a much later date. (Above, © 2002 photograph by Glenn Cuerden; below, © 2003 photograph by Glenn Cuerden.)

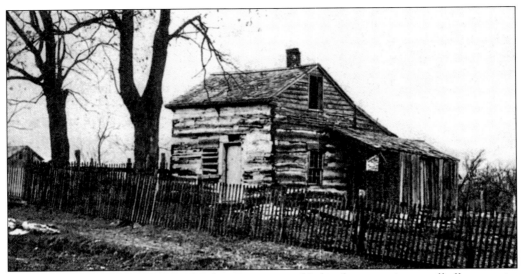

A TOWN LEFT VACANT. Mormon land agents remained behind, attempting to sell all properties in the desolate city, but to little avail. There were very few buyers and little wealth. Most properties were eventually sold at extremely low prices or foreclosed due to unpaid property taxes. The cabin pictured is thought to have belonged to Howard Coray. Brigham Young's home was purchased in July 1846 for $600. (Courtesy the Nauvoo Historical Society.)

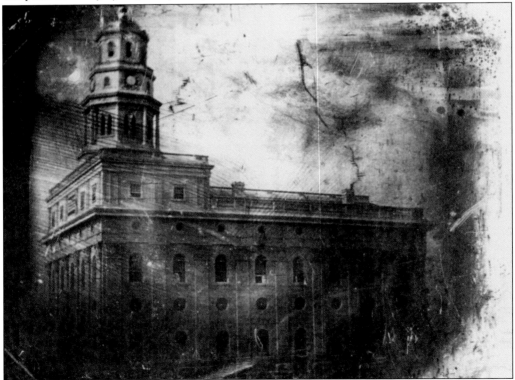

TEMPLE, 1846. This is one of the very few photograph known to have been taken of the temple. (Courtesy the Missouri Historical Society.)

Four

GERMAN IMMIGRANTS ARRIVE BETWEEN THE HISTORIC ERAS

Comparatively little has been documented about Nauvoo during the era between the Mormon settlement and the French Icarian colony. By the end of 1846, almost all Mormons had departed, and the former city of approximately 12,000 became almost vacant. An empty shell of a town remained. Some Mormons did stay behind for they were too old, too sick, or too poor to travel west. Many of these relocated, at least temporarily, to towns outside of Nauvoo where it was much safer. So did Joseph Smith's mother and various members of the extended family. Emma Smith (Joseph Smith's wife) and her four sons stayed behind but moved upriver to Fulton for six months.

Four years after the exodus, per one account, Nauvoo's population had grown again to 1,242. The era surrounding 1848 became a time of active growth and change. Grapes and wine soon became a major industry. By the mid-1800s, Nauvoo had become a mixture of many nationalities, but most residents were German and typically Catholic or Lutheran. Some Swiss, Irish, and English also settled here, but Nauvoo and nearby Warsaw remained primarily German towns. During this period, a lot was happening in the county and the nation. The Irish came to America, partly due to the potato famine. Germans and others nationalities were escaping political and economic problems, or military duty, in their own native countries. By the end of the 1800s, over 12 million immigrants had settled in America.

Growth in Hancock County was rapid after the 1830s. With a population of 483 per the 1830 U.S. census, the county ballooned as follows: 9,945 people in 1840, 14,652 in 1850, 29,061 in 1860, and 35,935 in 1870. These statistics are courtesy of Mary Siegfried's article in *History of Hancock County, Illinois*. The decades afterward show a slow decline, which was typical in the Midwest due partly to industrialization and a gradual shift of population from rural communities to larger city areas. By 1960, the entire population of entire Hancock County, with no large cities, had dropped to 24,574, only twice Nauvoo's 1844 population.

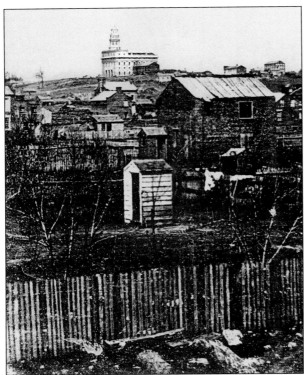

NAUVOO GROWS AGAIN. After the 1846 Mormon exodus, the town remained almost vacant for a while. The empty city is shown here in a daguerreotype around 1846. But Nauvoo soon took on a new direction as more German immigrants (in addition to a large French Icarian colony) continued to settle in the area. People of other nationalities moved here also, although to a lesser degree, including Irish Catholics and immigrants from Prussia. (Courtesy the Nauvoo Tourist Center.)

GERMAN THE MAIN LANGUAGE. Nauvoo became one of the largest German-speaking settlements in Illinois. German was spoken in homes, churches, and business establishments. It was even taught in schools for approximately 50 years. This practice was abruptly discontinued when the onset of World War I made speaking German highly unwise. (© 2003 photograph by Glenn Cuerden.)

JOSEPH'S WIDOW. Emma Smith, an unsung hero of hardship, remained in Nauvoo with her four sons, Joseph III, Alexander, Frederick, and David. Saddled with a huge debt and countless problems, she nevertheless retained the Smith properties and became an accepted and honorable citizen of the new Nauvoo community. She married Maj. Lewis C. Bidamon in 1847, and together they operated the Nauvoo Mansion House as a hotel. Eventually it was enlarged to 22 rooms. Emma Smith lived here until she died. (Photograph property of Glenn Cuerden.)

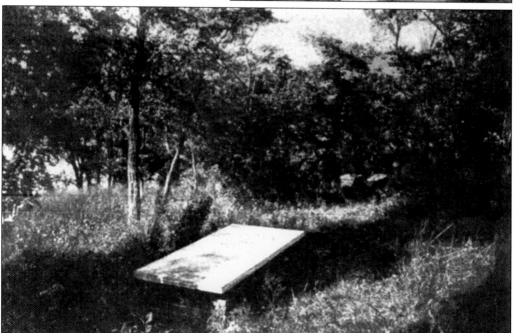

EMMA SMITH DIES, APRIL 30, 1879. Emma Smith was buried just southeast of the house on the Smith Homestead, which was also the secret burial place of Joseph and Hyrum Smith. (Courtesy Marilyn Kraus.)

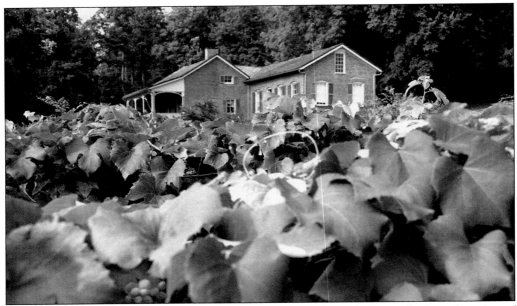

GRAPE INDUSTRY IN NAUVOO, 1846. Nauvoo's grape industry began with the cultivating of grape roots by German settlers John Sillar and John Tanner. Some other early vintners were Alois Rheinberger, Emile J. Baxter Sr., George Ritter Sr., August Berger, and Henry Schneider. Oral history credits a German Catholic missionary, Father Alleman, with actually bringing the first grapes into the area. Germans and other settlers expanded grape production, and John Sillar produced 80 gallons of wine from his white Catawba grapes in 1851. Sillar increased his production to 360 gallons by 1855. This Alois Rheinberger home and first vineyard became a part of the Nauvoo State Park in 1950. (© 2002 photograph by Glenn Cuerden.)

RITTER PRESS HOUSE. George Ritter Sr. was the owner of this structure and the Prospect Hill property, which later become a part of the Nauvoo State Park. A German vintner, Ritter operated a wine press in this stone cellar. He was a shrewd and wealthy businessman and the owner of many major local operations during the last half of the 1800s. (© 2005 photograph by Glenn Cuerden.)

THE WINE INDUSTRY. Icarian Emile J. Baxter Sr. expanded his operation and became a major vintner from the 1860s until 1919, when wine making was temporarily halted by Prohibition. In 1936, his sons resumed operation as the Gem City Vineland Company. The Baxter Winery and vineyards operate to this day under the fifth generation of Baxter families as the oldest continuous business operation in Nauvoo.

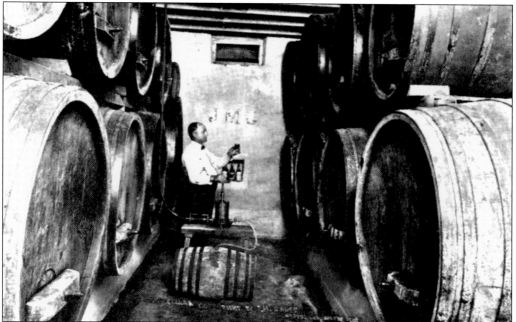

WINE PRODUCTION, C. 1948. Mike Gross is shown with his wine-testing equipment and giant casks in his large wine cellar on the north hill. During the height of the industry in the 1880s, there were around 60 stone wine cellars in Nauvoo. There were 47 remaining in the 1950s. (Photograph by Robert Hall.)

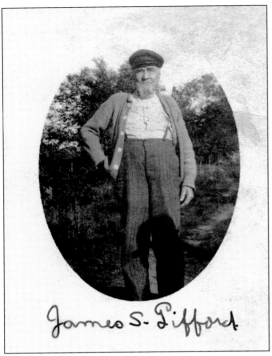

JAMES S. GIFFORD. James S. Gifford moved to Nauvoo with his parents in 1847 from a coal-mining region in Pennsylvania. He was a man of many professions who lived a colorful 95 years. An expert river man, he served as engineer and captain on all types of riverboats for 55 years. A post rider in the winter of 1847, he delivered mail by horseback between Oquawka and Warsaw. Soon after, he drove the stagecoach route between Oquawka and Quincy. He also farmed for a short period (unsuccessfully) and served as a carpenter during winter months when the steamboats were not running. He even worked on the interior of the Mormon temple. (Photograph property of Mary McKoon.)

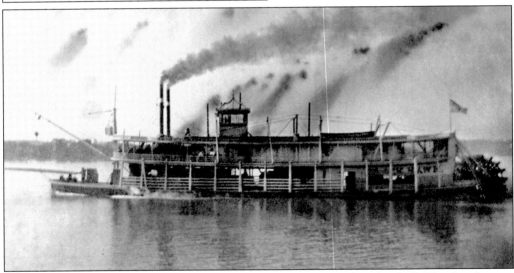

FERRIES AND STEAMBOATS. Early ferrying across the river was done by skiff. The first ferry in Nauvoo was the *Iowa Twins*. It was owned by the Mormons and was wrecked in an 1846 ice jam. James S. Gifford soon embarked on his own ferrying business between Nauvoo and Montrose after he moved here in 1847. He and a partner had the *Iowa* built in 1851. It was also eventually destroyed in an ice jam. Steamboats and ferryboats became very popular on the Mississippi. They were used for transportation up and down the river, for short pleasure excursions, and to ferry goods and people across the river. River transportation was in its heyday from approximately 1850 to 1870. This large steamboat traveling upriver is a stern-wheeler and is probably from the 1860–1880 era. (Courtesy Mary Logan.)

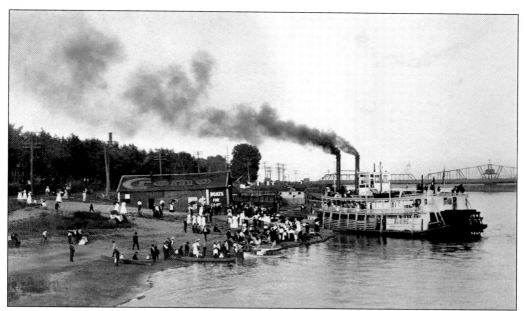

RIVER HISTORY. The river continued to play a part in Nauvoo's history down through the decades. Steamboats were very popular for holiday excursions to neighboring river towns in the 1870s and 1880s. Destinations were Burtin Grove in Burlington, and Quincy, Canton, Keokuk, and Mormon Springs. This stern-wheeler is docked at Fort Madison, and everyone is dressed up in his and her Sunday best.

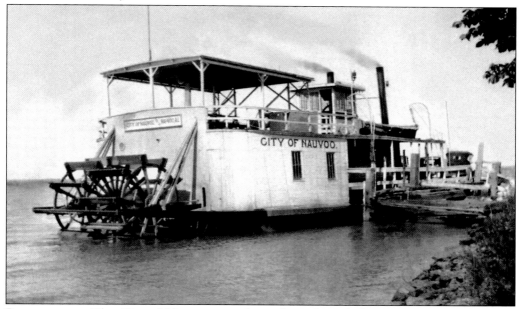

PADDLEBOATS. The *City of Nauvoo* carried people and goods between Nauvoo's ferryboat landing at the end of Parley Street and Montrose, Iowa, from 1884 until 1946 when it, also, was destroyed by an ice jam. Long-serving, it was Nauvoo's 9th or 10th ferry since the beginning of the Mormon era. In 1937, a paved highway began to hurt this ferry operation. Hauling was soon done by truck.

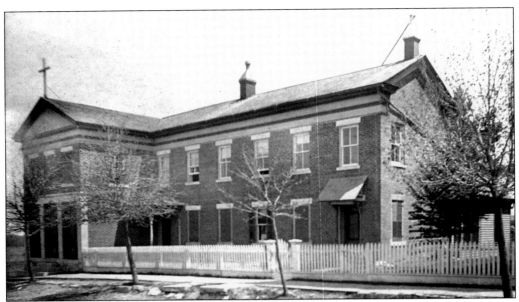

ST. PATRICK'S CHURCH. Fr. James Griffith organized the first Catholic church in 1848. It was located in the former Parley Pratt home and called St. Patrick's because of the many Irish Catholics residing in Nauvoo at the time. Serving as the church and rectory, the building was later called the Villa Marie. A new church (pictured below) was built directly to the south in 1873 under the direction of Fr. H. J. Reimbold. The church name was changed to SS. Peter and Paul, reflecting a predominantly German population. The Villa Marie was sold by the Benedictine Sisters to the local Catholic church congregation in 2001. The sisters also sold considerable Nauvoo property to the Mormon Church.

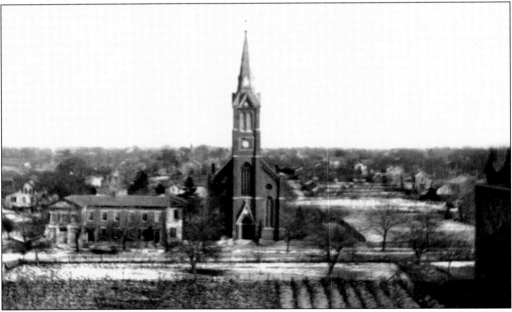

SS. PETER AND PAUL CHURCH. This early photograph shows the steepled church and the Villa Marie at the left. (Courtesy SS. Peter and Paul Catholic Church.)

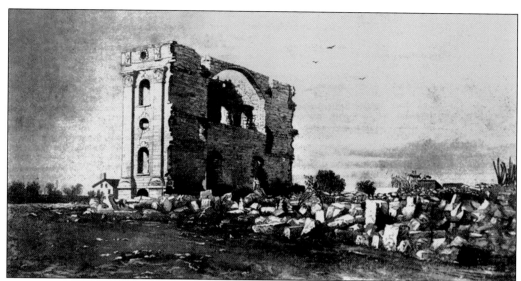

NAUVOO TEMPLE DESTROYED. This drawing by Frederick Piercy shows the temple in 1853. The temple was almost entirely destroyed by arson in October 1848, but the outside walls were left standing. Later, on his deathbed, local resident Joseph Agnew confessed to burning the Mormon temple. He implicated Judge Thomas Sharp of Carthage and Squire McCauley as his helpers. Some citizens had feared the Mormons would return if the temple remained, and it was claimed that a fund of $500 had been raised to pay Agnew to become an incendiary. But Agnew was such an "ornery cuss" that many doubt the truthfulness of his tale about the incident. Another theory, later circulated, was that Agnew was sent by the Mormons to burn the temple so that no one else could use it. The temple was damaged by further vandalism, then by an 1850 tornado. The remaining wall was taken down in 1873. The limestone blocks, originally mined from nearby quarries, were eventually recycled for various buildings and foundations in the area.

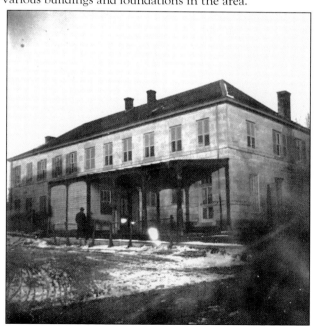

A NAUVOO LANDMARK. This structure was initially built around 1851 by the Icarians as their school on the southwest corner of old Temple Square. Constructed of temple stones, it served many purposes and became the Knaust and Bossler building at one time. The local Catholic church bought it in 1918, and it again became a school. Demolished in 1972, it was the last remaining Icarian structure. This photograph was taken when the building was used as the Nauvoo post office.

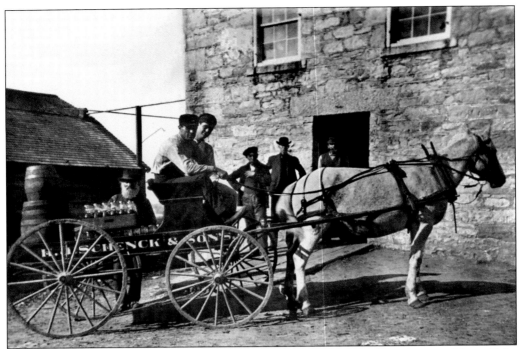

SCHENKS' BREWERY. German businesses began to flourish. Godfrey Schenk arrived from Celu, Kingdom of Prussia, in 1848. His brewery started as a small operation down by the river. Godfrey's sons, Peter and Herman, built this large brewery at the top of the Hill in 1859, and it operated until about 1908.

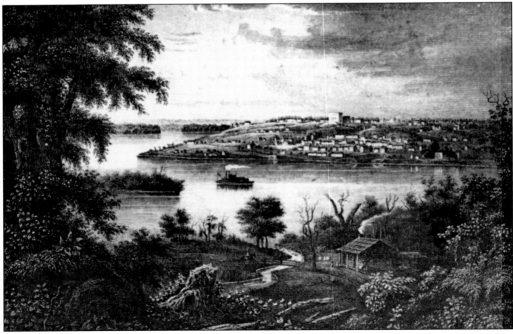

NAUVOO. This old woodcut depicts the town as it appeared from the Iowa shore around 1849.

Five

The Icarian Era in Nauvoo

The years between 1849 and 1858 were the period of a socialist, French Icarian experiment in Nauvoo. In 1839, Etienne Cabet had published a book, *Voyage en Icarie*, whose ideals were popular with the masses in France. His country was suffering from a severe depression, unemployment, and political unrest. Cabet envisioned a paradise in America not obtainable in France. He conceived a communal colony where culture was emphasized and each individual could work at a trade he loved best, each person receiving according to his need. Cabet arrived in New Orleans from France in early January 1849. His timing was not good. King Louis Philippe had just been overthrown, and a French revolution was in progress when Cabet's advanced guard arrived in the United States during the previous March. A first attempt of colonization in Texas failed. Cabet also found himself without the financial base or a large migration of people escaping France's King Philippe, which he expected. A commission was sent from his base in New Orleans to explore the city vacated by the Mormons. In late February 1849, his group voted to develop Nauvoo as their Icaria, and Cabet purchased property in Nauvoo. His colony arrived in March, and everyone was joyous. But after a few years, his idealistic dream did not progress as envisioned. Many of his "soldiers of humanity" from French cities were upper-class and not accustomed to, interested in, or trained for the hard work needed to survive on the Midwest frontier. Financial burdens also took a toll. The colony eventually rebelled under Cabet's rigid, idealistic leadership, and his American dream ended in disappointment and failure.

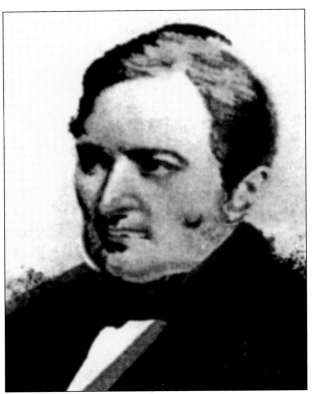

ETIENNE CABET. In March 1849, Etienne Cabet arrived in Nauvoo from France by way of New Orleans with about 275 French followers. The political situation in France was at a low ebb. Encouraged in France by the success of his well-received book on social-political reform, *Voyage en Icarie*, Cabet bought 12 acres in Nauvoo that had been vacated by the Mormons three years earlier. The parcel included 69 buildings per one account. He established an Icarian, socialist, communal colony, purchasing Temple Square and several surrounding Mormon buildings from Mormon land agents. He also acquired 663 acres of outlying farmland to support his communal experiment. Cabet was elected president with a cabinet of directors for industry, finance, agriculture, public instruction, and clothing and nourishment. (Courtesy Lillian Snyder and the Center for Icarian Studies, Western Illinois University Archives.)

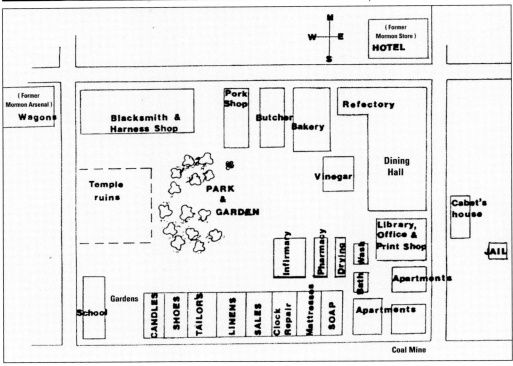

THE ICARIAN COLONY. The Icarians constructed a school, an assembly hall, and a communal dining hall. They also built wood-frame apartment buildings (shown above), workshops (separate for men and women), warehouses, gardens, and other buildings. Down by the river, there was also a coppersmith, tinsmith, foundry, laundry, flour mill, icehouse, and distillery. Many in the colony were teachers, artists, engineers, musicians, and other professionals. Living conditions were uniformly simplistic, even spartan. Fraternal living was strictly regulated by Cabet, and very rigid principles of family morality and sexual purity were practiced.

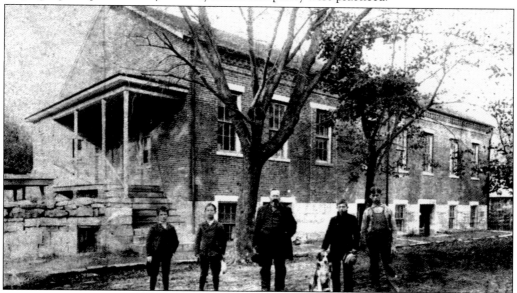

ICARIAN DINING HALL. The dining hall is pictured here in 1888 when it was used as the Nauvoo City Hall. The old hall became known as the Opera House from about 1898 until it burned down in 1938.

THE GOOD YEARS. The years 1850 to 1854 were the Icarians' best years in Nauvoo. By July 1852, there were 365 members in the colony. A high of 469 people was listed in the 1855 Illinois census. Life was structured on a high plane of intellectual and cultural activity. Music, drama, dance, reading, and philosophy were highly regarded, and organized events were regularly scheduled with clocklike precision. The general public was invited to concerts, which were widely attended by the outside community. (© 2002 photographs by Glenn Cuerden, permission of Lillian Snyder.)

EMILE J. BAXTER SR. Emile J. Baxter Sr. moved to Nauvoo in October 1855 to serve as secretary to Etienne Cabet just as the colony's financial burden was taking its toll and the governing Icarian general assembly was starting to disintegrate. Baxter stayed and would soon play a key part in Nauvoo's grape and wine industry. (Courtesy Lillian Snyder.)

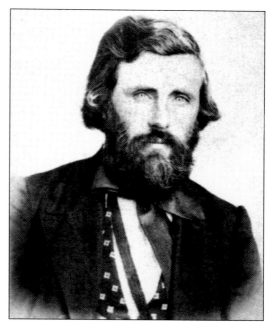

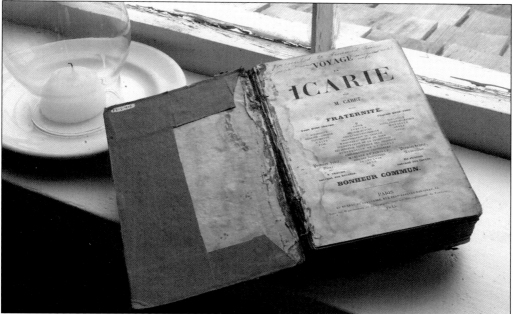

INTERNAL STRIFE. A great many of the Icarians were educated professionals and not adept at farming or working as laborers, skills that were crucial to success here. Conflicts gradually accelerated due to Cabet's strict 1853 edicts, "Forty-Eight Articles for Living." By the fall of 1854, financial panic had settled in, and things were not going smoothly in Cabet's utopia. Cabet had become embittered by many actions of his followers, by their departure from his strict moral codes, and by the accumulation of personal belongings by some individuals, a practice Cabet forbade. Pictured is an 1845 French edition of Cabet's book. (© 2005 photograph by Glenn Cuerden, permission of the Rheinberger Museum.)

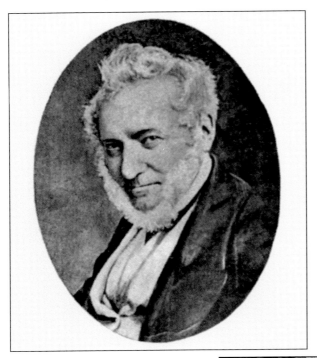

ICARIANS LEAVE NAUVOO. By the end of 1856, after much feuding, the colony disbanded and most Icarians broke away from Etienne Cabet. Some stayed in the area to purchase and farm homesteads. Some became local businessmen. Extremely discouraged, Cabet relocated with his own group of 179 followers to St. Louis in November. Later that same month, he suffered a stroke and died soon after at age 68. Some colonists moved on and developed a moderately successful colony elsewhere at Corning, Iowa, and later in Cloverdale, California. (Courtesy Lillian Snyder.)

LILLIAN SNYDER. Today no original structures remain in Nauvoo to document the Icarians' period of history. For decades, local Icarian descendent Dr. Lillian Snyder had been the main crusader in keeping this important history alive right up until the time of her death in November 2005. (© 2003 photograph by Glenn Cuerden.)

Six

Nauvoo Expands Again in the Mid-1800s

Never a bonanza of wealth or a great source of romance like the myths of Buffalo Bill, cowboys and Indians, and the Wild West, the Midwest still provided a comfortable, sustainable living for early settlers and later residents. By 1860, Nauvoo had become a stable community. It reached a high point in 1870 with 1,578 inhabitants and tradesmen. According to the U.S. census, 1,031 were native, 547 were foreign, and all were white. Hancock County reached the zenith of its growth around 1860 and had developed into a stable agricultural community with settlers farming the fertile Mississippi River valley and rich prairie soils. Although it played a crucial role in the days of exploration, fur traders, and early settlers, the Mississippi River valley was not the major factor in the area's long-term economy. Most of the prairie, with its tall grasses, had been tilled by the mid-1800s. Industrial progress was being made. Cyrus McCormick invented the grain reaper in 1834, and it soon reduced the cost of harvesting.

The first functional steamboat was built by John Fitch in 1787, but it did not find commercial success until around 1807. Robert Fulton tested a side-wheel paddleboat in 1803 and conducted tests (on the Hudson River) using a steam-powered Boulton and Watt engine in 1807. Major industries developed up and down the Mississippi and other river tributaries—logging, travel by steamboat, showboats, and ferryboats, and the shipment of goods by steamboats and then by barge. Each, in its turn, became a major means of commerce. Development of a railroad system and the paving of major highways eventually curtailed the use of river systems for travel and for the shipment of goods, but the Mississippi still remained a very important navigational and commercial route.

MARK TWAIN. In 1855, Samuel Clemens moved 55 miles upriver from his boyhood home in Hannibal, Missouri. While in Keokuk, Iowa (slightly downriver from Nauvoo), he set type for his brother, Orion Clemens, who owned a print shop there. Samuel's wit and humor were already evident in newspaper articles and local speeches. He left the area in October 1856 to embark on the first of his many worldwide adventures—and tall tales. From 1857 to 1861, he became an apprentice, then a pilot, on Mississippi riverboats. From these experiences, Samuel (born 1835) created his pen name, Mark Twain (a riverboat term with twain meaning two fathoms deep). The drawing above, by John Schroeder, appeared on an 1859 map of Hancock County, depicting a view of Nauvoo from the river. The illustration below, from an early edition of *Huckleberry Finn*, is typical of a Mississippi River scene during the period.

THE PONY EXPRESS. April 3, 1860, kicked off the first official 1,966-mile, 11-day transcontinental pony express ride. The express bridged the gap where there was no telegraph service between the coasts. It carried mail between St. Joseph, Missouri, and Sacramento, California. In October 1861, the last section of the transcontinental telegraph connected both coasts. This spelled death for the short-lived, cross-country pony express.

THE FRONTIER MOVES WEST. By the 1870s, the wild and lawless edge of the frontier had shifted well beyond the Mississippi River. In 1867, Col. George Nicholes wrote an exaggerated, colorful account of "Wild Bill" Hickok (James Butler Hickok) in an issue of *Harper's*. Billy the Kid shot his first victim in 1877. In the eyes of the nation, Nauvoo and the Mississippi River valley had become dull and quiet by comparison.

REWARD
($5,000.00)

Reward for the capture, dead or alive, of one Wm. Wright, better known as

"BILLY THE KID"

Age, 18. Height, 5 feet, 3 inches. Weight, 125 lbs. Light hair, blue eyes and even features. He is the leader of the worst band of desperadoes the Territory has ever had to deal with. The above reward will be paid for his capture or positive proof of his death.

JIM DALTON, Sheriff.

DEAD OR ALIVE!
"BILLY THE KID"

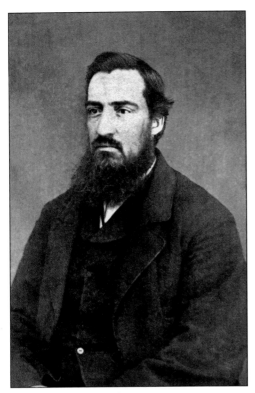

JOSEPH SMITH III. Joseph Smith III (pictured) was the eldest son of Emma and the prophet Joseph Smith. The Mormon prophet, before his death in 1844, is said to have blessed his son on three separate occasions as eventual successor to the church presidency. Some maintained he was the rightful heir to leadership. However, he was only 11 at the time of his father's death. Others within the church were vying for leadership and power themselves, and Joseph Smith III was discounted. (Photograph property of Glenn Cuerden.)

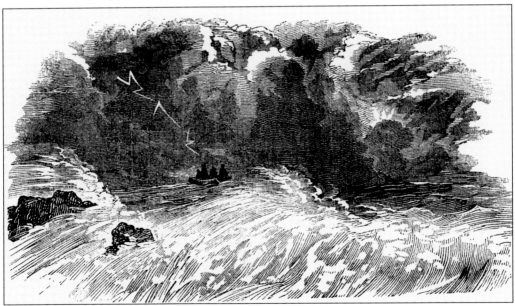

RLDS PRESIDENT. In 1860, James Gifford rows his close friends Emma Smith and her eldest son, Joseph Smith III, from Nauvoo across the Mississippi in a skiff during a dangerous spring storm. This is the first leg of the Smiths' trip to the Amboy Conference on April 6. There Joseph III was ordained as the first president of the RLDS. (Illustration property of Glenn Cuerden.)

EARLY RLDS BACKGROUND. This building, pictured in 1949, became the RLDS's Nauvoo church from around 1916 until 1988 when a new church was built. The RLDS had its beginning in 1851 when two former members of the original Mormon Church, Jason Briggs and Zenos Gurley Sr., initiated the reorganization. Both were leaders of congregations in the vicinity of northern Illinois. They approached Joseph Smith III to become their president and leader in late 1856, in great part due to his direct lineage. Joseph and his mother had shied away from religion due to all the problems encountered in the past. In 1860, after much thought, Joseph agreed to accept church leadership. The first church meeting held in Nauvoo was in the original Smith Homestead House where Joseph III and his family now lived.

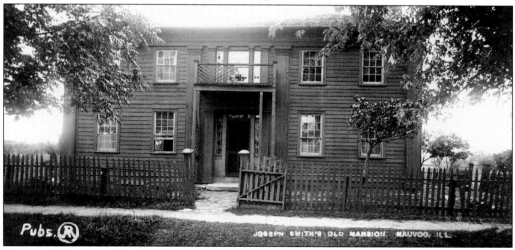

NAUVOO MANSION HOUSE. After Joseph Smith's death, his widow, Emma, remained in Nauvoo with her four sons. She married Maj. Lewis C. Bidamon, and for many years, they successfully operated the Nauvoo Mansion House as a hotel. At one time, it contained 22 rooms with a foundation 140 feet long.

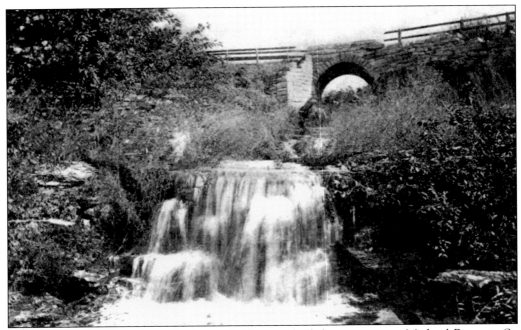

FISHER'S POINT, 1861. An arched stone bridge was built by stonemason Michael Baumert Sr. near the river's edge at Fisher's Point. This allowed easy crossing over the drainage ditch on Nauvoo's Flats. The original ditch was dug by the Mormons in the early 1840s to drain the swampy areas of lower Nauvoo in order to build homes. Today the stone bridge remains a local landmark and marks the beginning of the 1937 Nauvoo-to-Hamilton Scenic River Road.

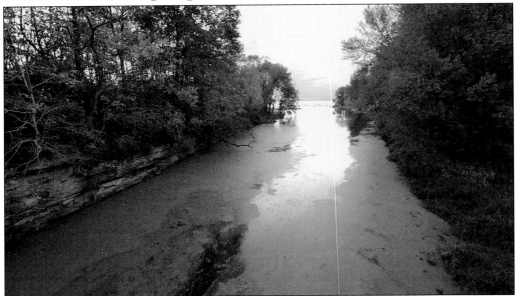

A PLANNED RAILROAD, 1867. A bridge span was built over Sheridan Creek, three miles south of Nauvoo, for a planned Warsaw and Rockford Railroad. However, neither a railroad nor a new town envisioned there ever became a reality. Nauvoo was also bypassed. (© 2005 photograph by Glenn Cuerden.)

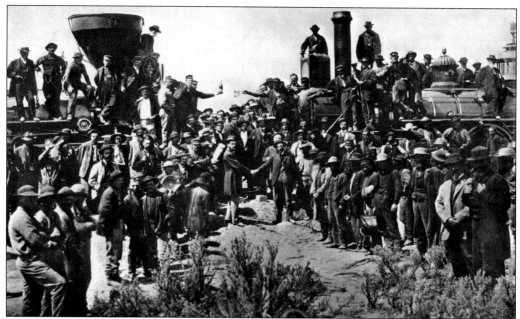

INTERCONTINENTAL RAILROAD, 1869. From the East Coast to the West Coast, the nation quickly became united by stage lines, by the pony express, by telegraph, and then by rail. On May 10, 1869, the symbolic Golden Spike was driven at Promontory, Utah. The intercontinental railroad industry altered the course of commerce nationwide. However, a railroad or spur passed through nearby towns and bypassed Nauvoo, somewhat limiting its commerce. The closest rail was upriver at the Niota/Fort Madison river crossing.

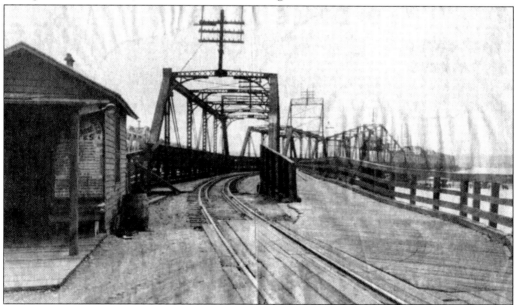

FORT MADISON BRIDGE. In 1888, this Santa Fe Railroad bridge connected Fort Madison, Iowa, with Illinois a few miles upriver from Nauvoo. On each side of the track was an access for passage by wagons, carriages, and pedestrians. Previous crossings were by boat or ferry.

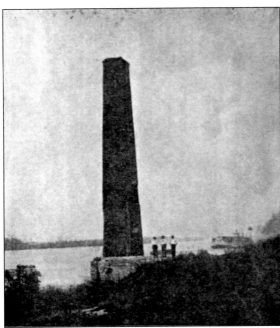

A River Landmark. This 70-foot chimney was all that remained of the old Iking flour mill, destroyed by fire in the early 1900s. It stood for years at the edge of the river and served as a landmark for river pilots. It eventually collapsed in 1922.

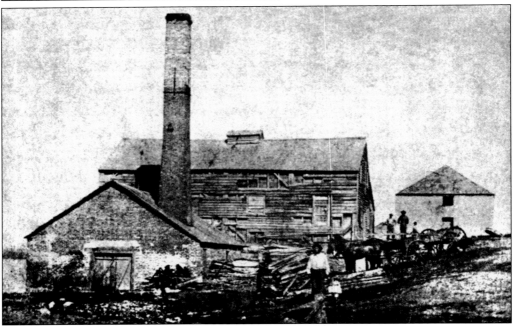

Mills. Mills served an important function in the settlement of the Midwest. There were both sawmills and gristmills. Most were either water- or steam-powered. The earliest known mill in the area was built around 1831, and an 1836 mill at Venus was powered by horses. Typically grain (grist) was taken to the mill by farmers to be ground into flour. The miller retained a portion of the product for his services. This Nauvoo flour mill was owned by Andrew Urban from 1869 to 1877. The small building at the far right in this picture is a grout (cement) house built by the French Icarians. (Courtesy the Hancock County Historical Society.)

THE FERRYBOAT LANDING. This landing was a landmark and focal point of activity for over a century. Nearby is Dundey Island, one of several islands that was flooded by the dam in 1913. William and Polly Dundey moved to Nauvoo in 1851, bought the landing property, and entered the ferry business when William purchased the *Iowa*, owned previously by river man James Gifford. Later the *A. Burtin* was purchased, rebuilt in 1883, and renamed the *Dundy*. The family built the *City of Nauvoo* in 1884. This illustration shows Dundey Landing, a Dundey home, and the Dundey Elm (a landmark used by river men) at the foot of Parley Street. William and his sons operated ferries here for 50 years. One son, George, dropped the *e* and changed his name to Dundy. This pencil drawing was done by native Joseph Kirschbaum. (Courtesy Katherine Clark Newbold.)

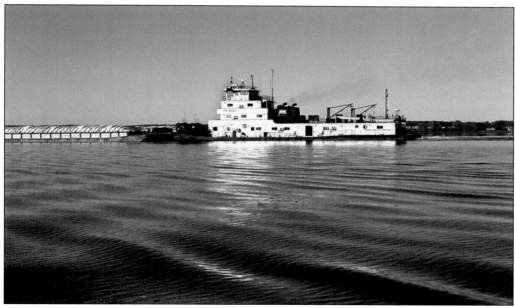

THE RIVER ECONOMY CHANGES. Steamboats eventually gave way to large, modern-day, flat-bottom barges powered by tugboats with diesel engines. Barges became the main source for transporting large quantities of grain, coal, phosphate, oil, all types of building products, and other commodities up and down the Mississippi. In 1956, 7,740,000 tons of cargo was transported. (© 2003 photograph by Glenn Cuerden.)

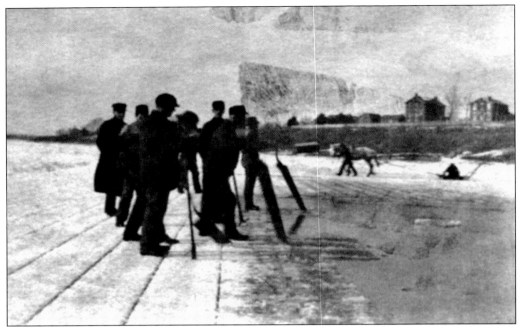

ICEHOUSES STORE ICE FOR SUMMER. The Mississippi was an important factor influencing lifestyles in the region. The river served many purposes, a livelihood for fishermen, recreation, even the main source of ice for iceboxes during summer months. Ice was sawed into blocks then sledded to an icehouse and packed with sawdust, to be sold later. It was always a good idea to have a beverage supply available to ward off the cold while others did all the sawing. Early merchants Herman Schenk and Theo Ochsner appear to have perfected the technique.

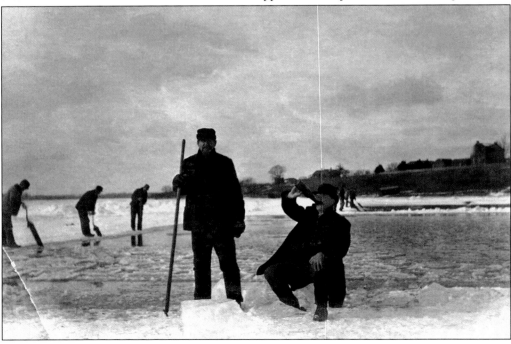

THE RIVER. The Mississippi River afforded a unique source of peaceful entertainment and teemed with fish. Catfish, carp, perch, buffalo, hackleback (a type of sturgeon), and eel were plentiful. Clamming was also popular. Buttons were cut from certain types of shells, and there were several button factories.

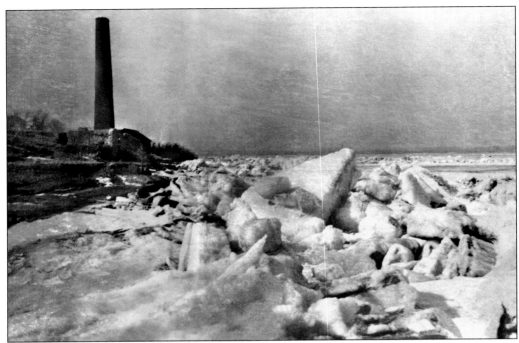

STORMS AND DISASTERS. The life span of many paddle steamboats was brief due to fire or storms. Some were caught in sudden freezes and crushed by ice floes. The *Iowa Twins* (1839–1846), thought to be pictured below, was wrecked by ice and remained near the Nauvoo landing until its hull eventually rotted. The *City of Nauvoo* served from 1884 until it was trapped and crushed by ice floes in 1946.

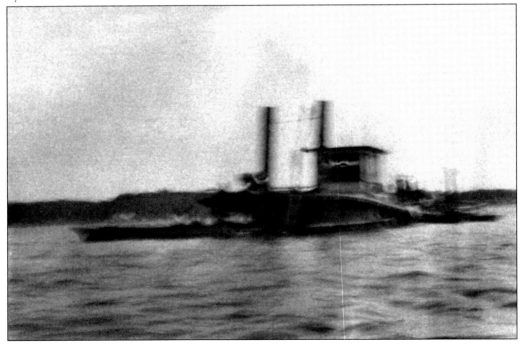

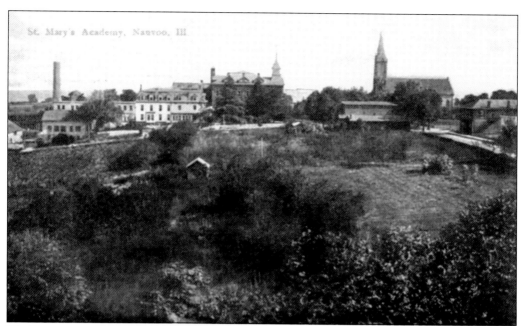

SS. Peter and Paul Catholic Church. The Catholic church enjoyed a long, active history in Nauvoo. Missionary priests stopped in 1820 while traveling on the river. Records indicate Fr. John St. Cyr was the first to visit. In 1848, Fr. James Griffith became the first resident pastor. Rev. H. J. Reimbold conducted the first mass in the newly completed (1873) SS. Peter and Paul Catholic Church (shown at the upper right), which had a seating capacity of 360. This postcard shows the complex as seen from the west in the late 1800s.

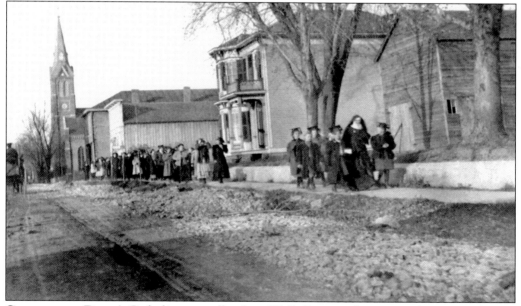

Graduation Day. A Catholic nun walks along Wells Street with a group of young graduating girls in 1880–1890s. The church can be seen behind them. The buildings at the right stood on the west side of Temple Square.

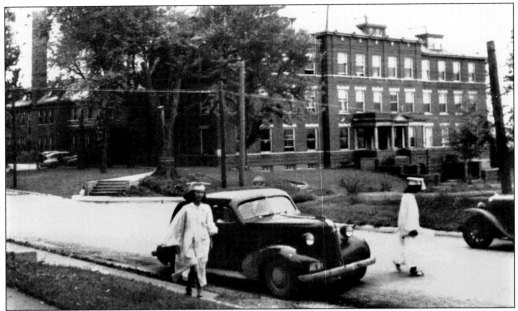

ST. MARY'S ACADEMY FOR GIRLS. In October 1874, five Benedictine Sisters arrived in Nauvoo from Chicago and started a girls' boarding school, which steadily grew in size and reputation. It became the St. Mary's Academy for Girls. This photograph shows some of the girls on graduation day before World War II with Benet Hall in the background.

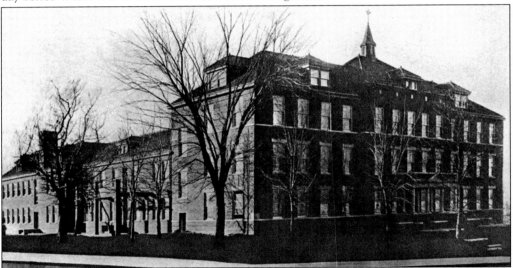

SPAULDING INSTITUTE. This is one of the largest buildings ever constructed in Nauvoo. It was built by the Benedictine Sisters in 1907 as the Spaulding Institute, a home for boys through the eighth grade. The government leased it as a vocational training school for disabled veterans in 1920. In 1926, it was renamed St. Edmund's Hall and used as a boys' grade school, then as a convent and motherhouse for the sisters in 1940. When a new priory was dedicated in 1954, it was used for classrooms and dormitory space for the expanded St. Mary's Academy. After lying dormant, out-of-date, and in disrepair for a period, it was razed in 1976 (as Benet Hall). It has operated under five separate names during its 69-year lifetime. (Courtesy Ida Lutz.)

CYCLONE DAMAGE, 1876. A cyclone did much damage in Nauvoo during July in this centennial year. It killed at least one and ripped the 140-foot-high steeple off the SS. Peter and Paul Catholic Church.

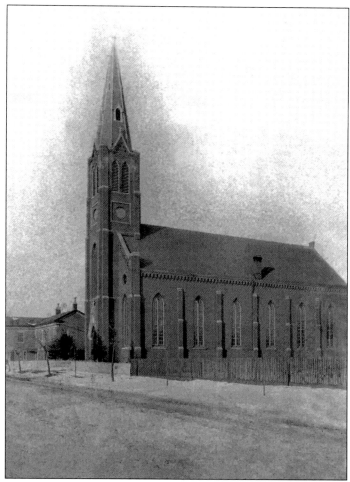

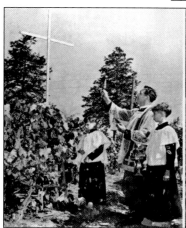
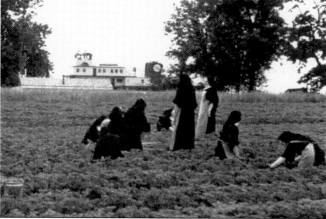

ACTIVITIES. This photograph from the mid-1950s shows sisters picking strawberries next to the river. Fr. L. C. Tholen, left, is blessing the grapes and grape harvest in 1941. Even today the Catholic church retains the largest congregation of all seven churches in Nauvoo.

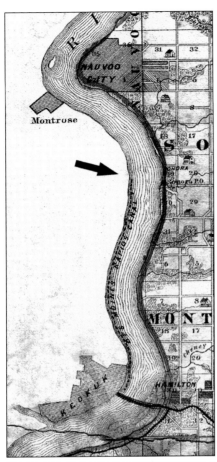

CANAL, 1877. A $4 million lateral canal was completed slightly downriver from Nauvoo, extending eight miles south toward Keokuk, Iowa. This canal ensured safer commerce up and down the Mississippi through the treacherous rapids along this stretch. Stone was barged across the river from the Sonora Limestone Quarry in Illinois, located just to the right of the Mount Mariah bridge as shown around 1900 in the postcard below.

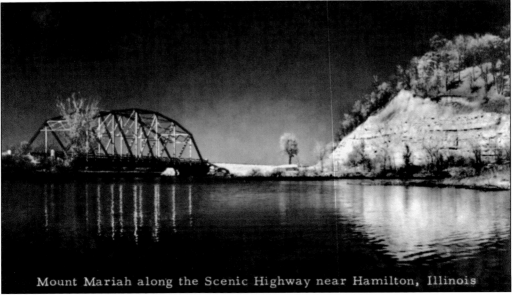

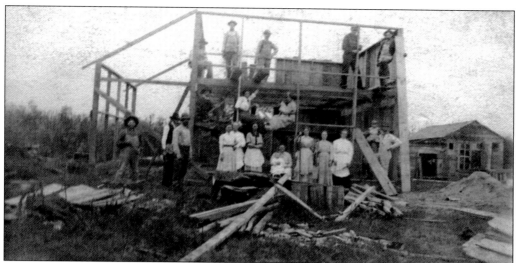

HOUSE RAISING, 1800S. Rural life as depicted on this old postcard shows a true sense of community. Neighbors usually pitched in to help build a new home. Shivarees were common events shortly after a newly married couple moved into their home. This was the rural, neighborly version of the more modern welcome wagon. Unexpectedly one night, when everyone should be asleep in bed, all the neighbors gathered silently around the house. On cue they made all the racket they could, banging on pots and pans, blowing horns, hollering, ringing cowbells, and indulging in other such nonsense until the couple woke and got up. Then everyone came inside for ice cream, homemade pie, or whatever the couple could scrounge up for the unexpected guests to eat. There was typically much local banter and kidding.

MODERN HOME BUILDING. This house was prebuilt in two sections then brought to the site on two large semitrucks. Final assembly was finished in half a day. This picture shows the first half being lowered into position by a small crew. (© 2006 photograph by Glenn Cuerden.)

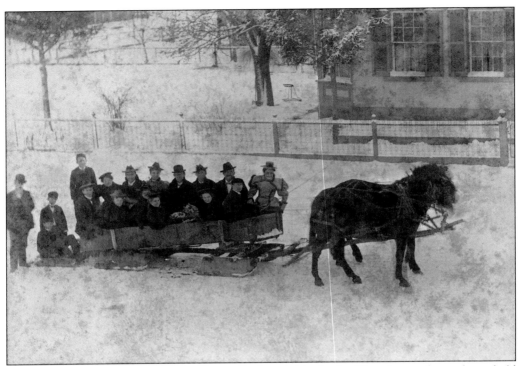

SLEIGHS, WAGONS, AND HAYRACK RIDES. Such activities in the Victorian era have always held a fascination. Bricks were often preheated and wrapped in a towel or blanket to provide a source of limited heat in these open-air, horse-drawn conveyances.

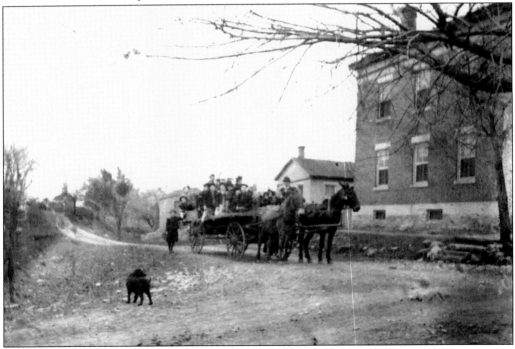

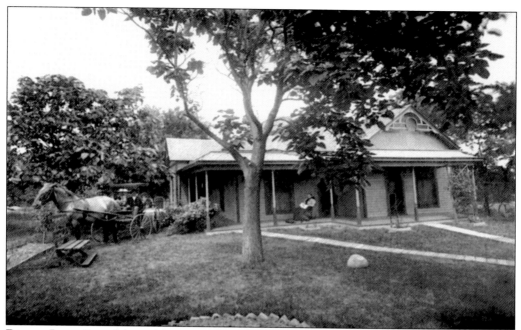

RURAL LIFE. Peaceful rural homesteads such as this one typically had rose and lilac bushes, grape arbors, and hollyhocks.

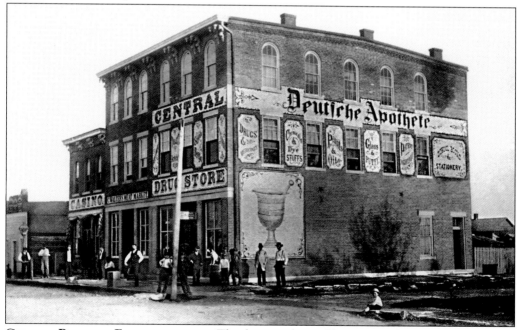

GERMAN BUSINESS ESTABLISHMENTS. This large multiuse Christian Walter Building was built by local stonemason Michael Baumert Sr. in 1877. Walter had a flourishing meat butchering business. Better known as the Walter Brothers Building, it was the home of the brothers' meat market for decades. The painted German advertisement around 1880 or 1890 for the apothecary (drugstore) is indicative of the large German population during the period.

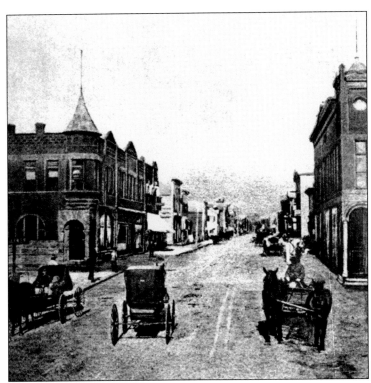

HORSE-AND-BUGGY DAYS. Mulholland Street is pictured at the top of the Hill looking east in 1906. The photograph below shows Nauvoo's Victorian era after a snowstorm in the late 1800s.

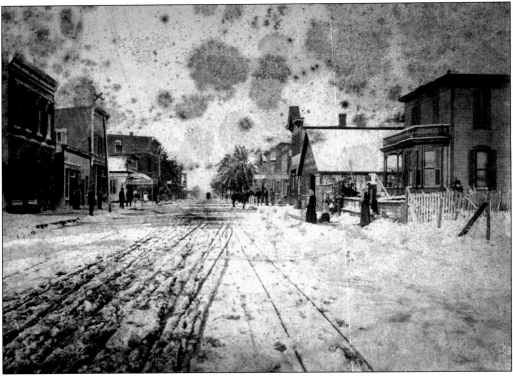

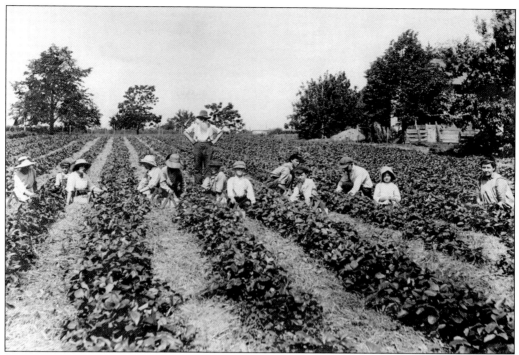

STRAWBERRY FIELDS. William Stahl became one of the area's early pioneers in growing strawberries. In 1889, he advertised for 1,000 strawberry pickers. Many temporary workers were brought from the Fort Madison area by steamboat. This photograph shows an 1898 strawberry patch. (Courtesy Mary Logan.)

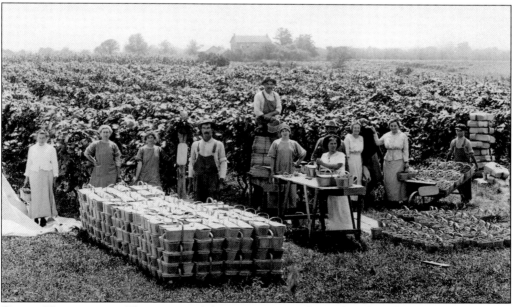

GRAPE HARVESTING. This is one of the many vineyards on the Flats during the late 1880s. (Courtesy Mickey and Beth Knipe.)

LOCAL PRODUCE, 1897. By now the area was a big producer of wine, table grapes, and strawberries. Abundant orchards provided apples, pears, peaches, and apricots, which complemented the local economy. Part of the production was shipped elsewhere; however, this photograph suggests that much was still consumed locally.

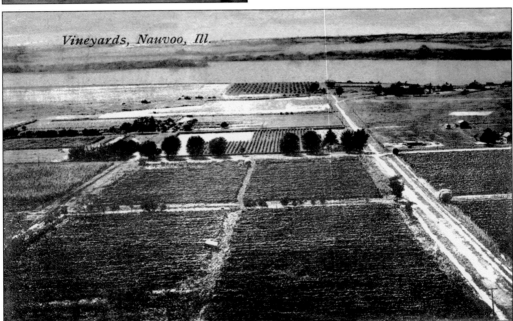

VINEYARDS ON THE FLATS. The Nauvoo 1897 grape harvest is one of the biggest on record—worth a whopping $50,000—with grape pickers earning 60¢ a day. As noted on this postcard, vineyards were abundant on the Flats. The end of the century boasted a high of over 600 acres of grape vineyards; however, the acreage dwindled considerably by the 1950s.

Seven

THE MIDWEST IS QUIET

Nauvoo was typical of much of the Midwest during the 1900s. It remained stable and did not grow. Some towns and many counties actually lost population as people gradually migrated to larger cities and as the nation became less rural. Per the national census and other reports, Nauvoo's population was as follows: 1,394 residents in 1860, 1,578 in 1870, 1,355 in 1880, 1,321 in 1900, 972 in 1920, 1,088 in 1940, 1,039 in 1960, 1,100 in 1980, 1,108 in 1990, 1,063 in 2000, and 1,108 in 2003. Residents were satisfied with the small-town atmosphere. A few new businesses came and some went. There were numerous establishments with a continuity extending for many generations in Nauvoo. It was a very congenial community.

Of course, there were occasionally a few differences of opinion. There was the time the school board elections attracted no interest at all. A group of club ladies who met often to embroider decided to do something about it. They went to the polls that day and collectively voted Mrs. John Reimbold and Mrs. L. Hudson into the two open positions. These elected ladies even started Nauvoo's first library. During the next April 1916 election the two, together with Mrs. J. Bortz, again appeared on the ballot. Strangely enough, even men who had not voted in several decades showed up at the polls this time. Thus ended women's reign in politics for a while.

In 1900, the first furnace was installed in Nauvoo. The first telephone system and switchboard arrived in 1901 thanks to Dr. J. Bortz. Wagons with springs replaced lumber wagons. Carriages without the horse started to show up early in the century. Dr. Bortz owned the first automobile in town, a Holdsman. (One source says it was a Cadillac.) People made their own *schmierkase*, *handkase*, *sauerbrauten*, and *kartoffel* puffers. They made their own soap out of ashes and lye, and they also made apple butter and fish bait. All were cooked over hot fires outdoors in huge kettles. One can only hope that the same kettle was not used for every purpose, but it probably was. Broomcorn brooms were manufactured for many years by John Kraft. Two canning factories were started, but they did not succeed. Handmade items were slowly being replaced by store-bought implements and furnishings, shipped from cities like St. Louis, Chicago, and Baltimore.

"**Modern Conveniences.**" The *Prairie Farmer* and the *Saturday Evening Post* magazines were rural mainstays—without television, cable, or the Web! This 1901 Ochsner advertisement for farm machinery appeared in the *Nauvoo Independent* newspaper. Joseph Ochsner operated an implement dealership. Radios were often operated by a wind charger or with Delco batteries. In 1908, only 8 percent of the households in the United States had electricity.

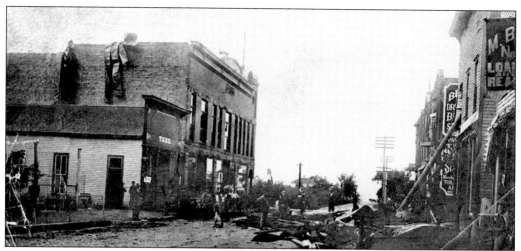

DAMAGE TO BUSINESS DISTRICT. Throughout the centuries, violent storms and sudden tornados periodically created problems in the area. On October 6, 1903, a tornado again hit Nauvoo and caused considerable damage. The roof was torn from the large two-story Ochsner building (above, left side). Debris slammed into the Singer building across the street. Longtime resident Marilyn Kraus nicknamed the street "tornado alley." (Courtesy Marilyn Kraus)

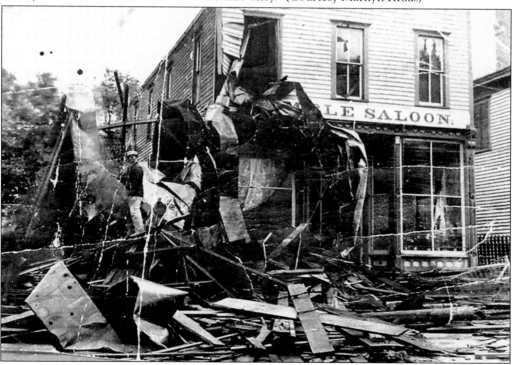

FORD, 1908. Henry Ford put his Ford Model T into production on October 10, 1908. "People can have any color they want, so long as it's black." Almost all roads were dirt, usually rutted, and very muddy during rainy periods. It appears that not everyone was a great driver.

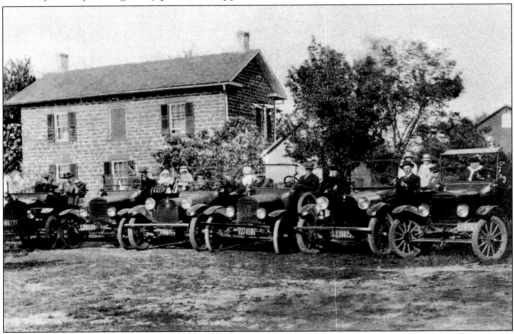

SUNDAY OUTINGS. It was great sport careening down rut-filled roads with the top down. Only the ladies with their bonnets minded the wind and dust. Some cars even had a rumble seat where the kids could ride.

GROUT BARN. There were a few grout buildings in Nauvoo (a cement-type mixture of lime powder, gravel, pebbles, and water). Some dated from the Icarian era, and some were built by Daniel Luce. The Bennett house dates from 1853. Some thought the rectangular slits in this hay barn were made for residents to defend themselves against enemies. They were actually for ventilation.

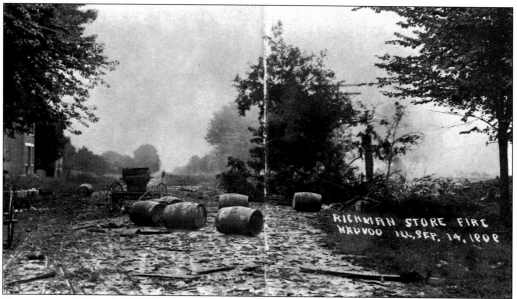

EXPLOSION, 1909. There was a big explosion of gasoline, turpentine, and kerosene in the Jacob Richtman store on Main Street on the Flats. Buildings and homes were badly damaged or destroyed. One person was killed, and debris was found hanging on telephone lines. (Courtesy Mary Logan.)

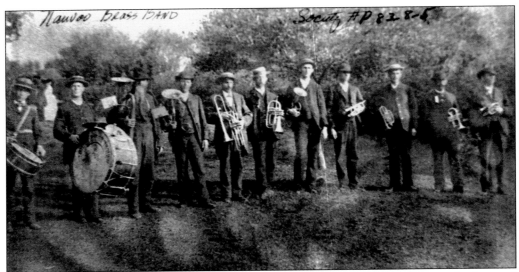

RECREATION IN NAUVOO. Bands and baseball were always popular. The Mormons had several bands during the 1840–1846 era. Later Nauvoo had numerous bands, the Nauvoo Brass Band (above) and the Union Brass Band being two of them. The women had sewing and quilting clubs. Baseball was introduced here in 1871 by Charles W. Welter, who previously played in New Orleans, and Ernest H. Reimbold, who played in St. Louis. Clubs were soon formed in the county. Nauvoo played Carthage, Dallas, and Fort Madison in tournaments.

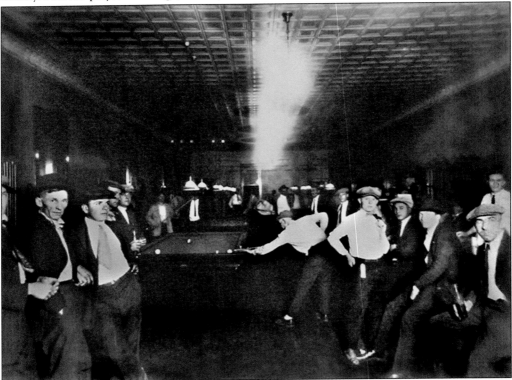

KRAUS BILLIARD PARLOR. John Kraus opened this popular hangout around 1915.

THE MERCANTILE BUSINESS. Lew Hudson, a salesman, and Hudson's son pose inside Hudson's grocery store. Locals often congregated around the potbelly stove during cold winter months.

HOME DELIVERY. During and after the war years, dry goods were often delivered by horse and wagon. Watkins Products and Fuller Brushes were sold door-to-door in rural areas.

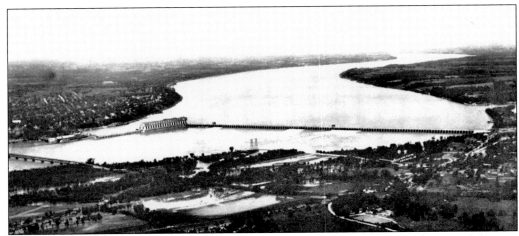

KEOKUK HYDROELECTRIC DAM. The Keokuk Dam's 1913 completion provided 133,000 kilowatts of electricity for the area. The increased water level allowed easy transportation through the treacherous 11-mile Des Moines Rapids, which previously dropped to a depth of only two feet during the season of low water levels. The dam claimed much land, including upriver islands. At the end of Nauvoo's Main Street, the water level rose 25–30 feet. Water partially submerged Water Street and the original home of Nauvoo's first permanent settler, Capt. James White. His stone house gradually deteriorated and was eventually torn down around 1928.

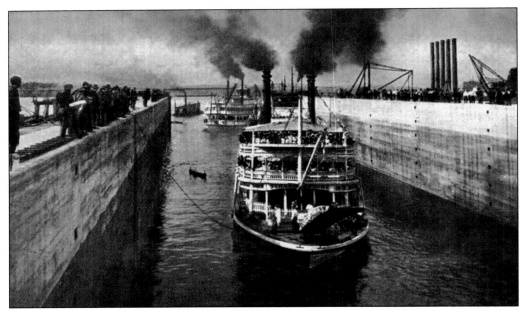

PASSING THROUGH THE LOCKS, 1913. The first large boat, an excursion steamboat, is pictured going through the locks after the dam's completion. This 358-foot-long and 110-foot-wide lock accommodated the largest steamboat of the time. In 1957, the lock was extended to 1,200 feet to handle long tows, three barges abreast and six long.

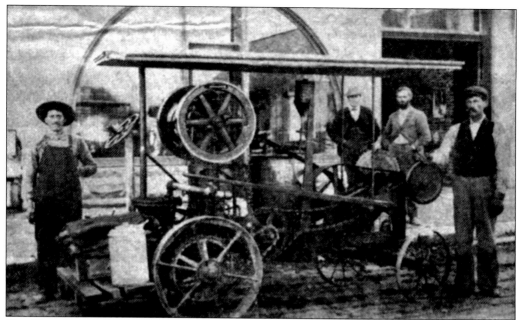

GAS PUMP, 1915. John "Repp" Repplinger, Nauvoo's resident inventor, designed and built the first gas pump visibly showing the amount of gas pumped, but he failed to patent it. Repplinger also built a number of cement-block houses, several automobiles (including one with two engines), a portable wood-sawing machine, a powered posthole digger, and a tractor-driven grape hoe. His greasy, creative hands were always up to something in his machine shop and garage.

TIDYING UP THE BUSINESS DISTRICT. This tractor was probably tilling the dirt street around 1915 in order to make it smooth and compact again. Mulholland Street was not paved until the early 1930s. The street was nicknamed "Mud-Holland" during the rainy season.

WORLD WAR I. The war ended in 1918. The airplane was quickly making the U. S. Cavalry obsolete. The Midwest was still very rural. About 80 percent of the population lived on and operated farms.

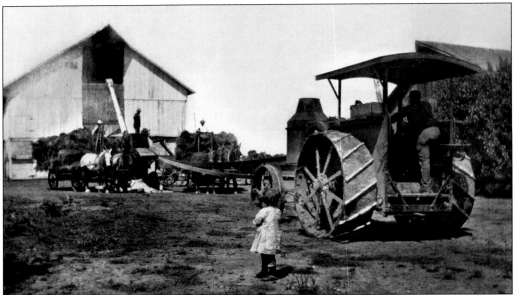

HARVEST TIME. Pictured in 1923, this threshing machine is being powered by Sam Bolton's 1915 oil pull tractor. As the grain was harvested and put into a wagon, the straw was blown into the barn. Grains typically threshed were oats, wheat, and occasionally rye, barley, and soybeans. (Courtesy Mary McKoon.)

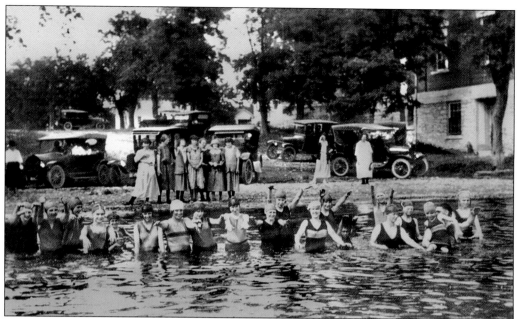

ACTIVITIES IN THE 1920S AND 1930S. Everyone takes a refreshing dip at the foot of Main Street. A 280-foot-long levee was built here in 1969, at the river's edge, as a precaution against possible flooding of the Nauvoo House, seen at the far right. A 1965 flood had delivered water right up to the doorstep.

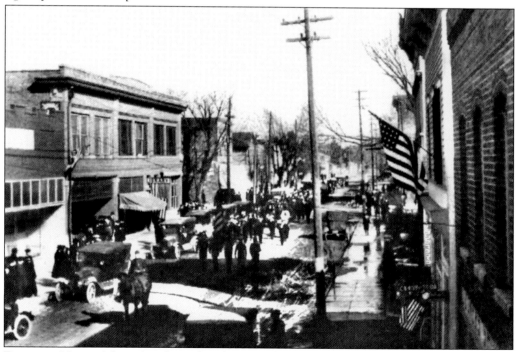

PARADES. Nauvoo's brass band marches down Mulholland Street around 1922. Parades were big events and were held every Memorial Day and on the Fourth of July.

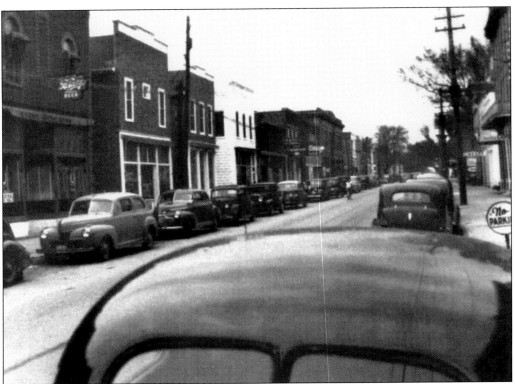

NAUVOO'S BUSINESS DISTRICT. Pictured is downtown, looking east along Mulholland Street in the early 1940s (above) and west in the mid-1950s (below).

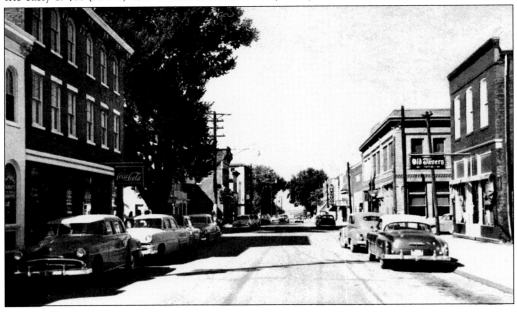

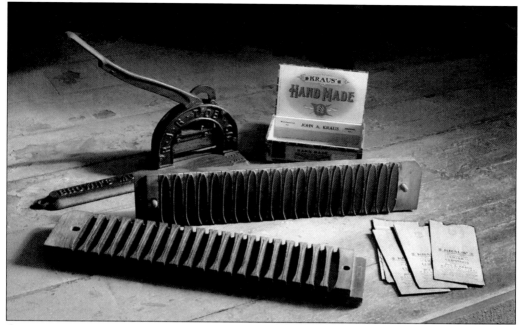

CIGAR MAKING. John Kraus arrived in Nauvoo from Keokuk and opened a cigar store in 1912. The tools pictured were used in John's cigar-making operation where he rolled, cut, and pressed his commercially sold stogies. Through diligence and hard work, he parleyed this beginning into a group of business enterprises by the time of his death in 1966. There were several cigar makers in town during the early 1900s. (© 2003 photograph by Glenn Cuerden.)

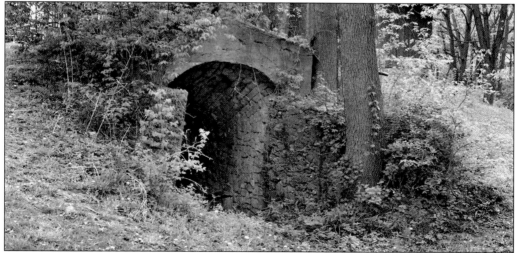

PROHIBITION, 1919. The National Prohibition Act was signed on October 28, 1919, prohibiting the sale of alcohol. The national ban proved to be extremely unsuccessful. Al Capone and Chicago soon become infamous. Bootlegging also occurred in the Nauvoo area due to the abundance of grapes and corn. These arched underground limestone caves in Nauvoo, a natural refrigerator, were ideal for storing beer and wine. Local accounts recall journeys by people leaving the Nauvoo area for Chicago, during the dead of night, in low-riding coupes with reinforced suspension. (© 2006 photograph by Glenn Cuerden.)

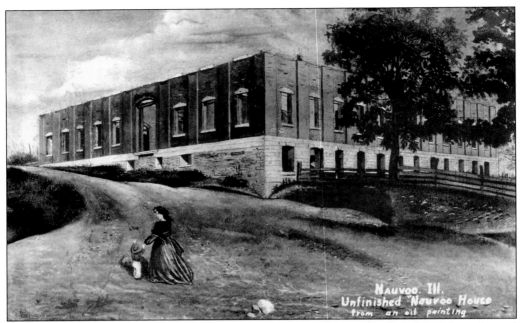

NAUVOO HOUSE. After Joseph Smith's January 19, 1841, revelation, this foundation for a planned hotel (across Main Street from his home) was started by his followers. It was never completed. When Joseph and his brother, Hyrum, were shot in 1844, they were secretly (and temporarily) hidden under the structure's basement floor by the family on June 29. At the time, it was feared that the bodies might be desecrated or stolen for the rumored reward. (The caskets were buried containing only sacks of sand.) Later the bodies were secretly buried elsewhere. In 1869, Emma Smith's second husband finished the Nauvoo House for their home, and they lived here until Emma died in 1879. The house and block were sold to the RLDS Church in 1915. This oil painting was done by Joseph and Emma's youngest son, David, who also wrote songs and poetry.

After President Smith of the Reorganized Church of Latter Day Saints had spoken, he called on James A. Gillen of the Quorum of Twelve to offer supplication and prayer to Almighty God.

At the close of the ceremony, Joseph B. Nelson, representing a committee of the Unity Club, placed a floral wreath over the remains, stating that the citizens whom he represented firmly believe the remains to be those of Joseph and Hyrum Smith.

The place where the remains were re-interred is about ten feet north of where the skeletons of the prophet and Hyrum Smith were found.

President Frederick M. Smith, Tholen, Wm. Hemmy and M. Richard. The affidavit is attested to by A. J. Schneider, notary.

A copy of this document will be recorded at Carthage, Illinois, as legal evidence of the veracity of the claim of the church that the remains of Joseph and Hyrum Smith are interred on the old family lot—now property of the church.

Members of the Latter Day Saints church here wish the Independent-Rustler to express their appreciation to the Unity Club and business men of Nauvoo for their floral offering. The wreath is to be placed in a permanent glass-covered case on the base of the monument.

PUBLICITY DIRECTOR GARDNER TELLS OF "INSPIRED" SEARCH —FINDING OF PROPHET'S REMAINS

By J. A. GARDNER
Director of Publicity, Reorganized L. D. S. Church

"Time yielded up another secret almost a century old when on January 16, in the little village of Nauvoo, Illinois, across the river Nauvoo. It is located in the vicinity of the Mansion House, near where still stand the old Smith homestead and the Nauvoo House, landmarks which have lasted nearly a century.

"On Wednesday, January 11, under the direction of W. O. Hands civil engineer of Kansas City, ex-

SMITH BODIES LOCATED. In 1928, the bodies of Joseph and Hyrum were located in a secret hiding place under the old springhouse foundation on the Joseph Smith Homestead. This had been their resting place since the Mormon era. They were exhumed and permanently placed (together with Emma's body) in the Smith family cemetery next to the Smith home. A total of 28 family members and friends were located here in a family plot very common during the era of pioneer settlers.

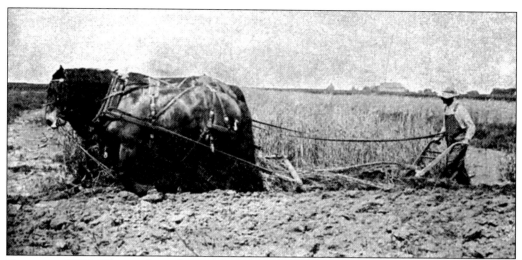

OCTOBER 1929. The stock market crashed, and the Great Depression hit America. The First Trust and Savings Bank in Nauvoo was mismanaged; it failed, and depositors lost their savings. The other bank, the Nauvoo State Bank, remained stable and weathered the bad times. Nauvoo and the heartland of rural America, with the ability to raise animals and crops, were much less affected than larger cities.

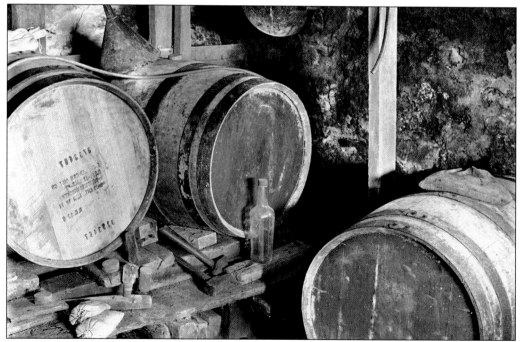

FEDERAL DEPOSIT INSURANCE CORPORATION. Established in 1933, the Federal Deposit Insurance Corporation provided better financial security for most Americans. Prohibition was also repealed in 1933. By Illinois law, each farmer could make a certain amount of wine for personal consumption (200 gallons) and many did. This basement wine cellar belonged to "Tuffy." He made approximately 50 gallons every year, a practice he continued for over 40 years. His basement was a very popular "tourist destination" for local neighbors and visitors. (© 1975 photograph by Glenn Cuerden.)

VINEYARDS. The Baxter Winery became the first commercially licensed manufacturer of wine in Illinois. The business was initiated by Emile J. Baxter Sr. in 1857 as the Golden Hills Vineyards. In 1895, the vineyard was passed on to his three sons and was renamed E. Baxter and Sons. It grew into one of Nauvoo's largest business operations and became the Gem City Vineland Company in 1936. By 1866, Nauvoo had 600 acres of vineyards and many vintners. The Nauvoo Fruit Growers and Shipping Association was also organized in 1913 with 150 members. Through the decades, grapes, wine, apples, pears, and peaches were shipped by water, rail, and trucks to locations in Illinois and to northern markets such as Minnesota and Wisconsin. Grape production declined considerably by 1955. This Baxter display shows old containers used in the grape industry. (© 2006 photograph by Glenn Cuerden.)

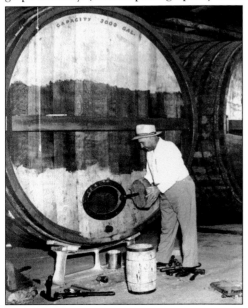

WINE PRODUCTION. Viticulture is the cultivation of grapes for making wine. Emil O. "Cap" Baxter is shown here around 1950 inspecting one of his custom 3,000-gallon wine casks crafted by coopers from Canton, Ohio. Cap was a third-generation operator of the Baxter industry. (Courtesy Mary Logan.)

LOVER'S GLEN. This landmark was a favorite picnic area. It was also a good place for necking. The limestone outcropping at the base of a small creek just below Nauvoo is fed by an ever-running spring, which empties into the Mississippi below the falls. This waterfall, as it appeared in an early-19th-century postcard, was eventually known by three different names, Seven Falls, David's Chamber, and Lover's Glen. Although renamed David's Chamber in recent years, it is more widely known as Lover's Glen by longtime local residents.

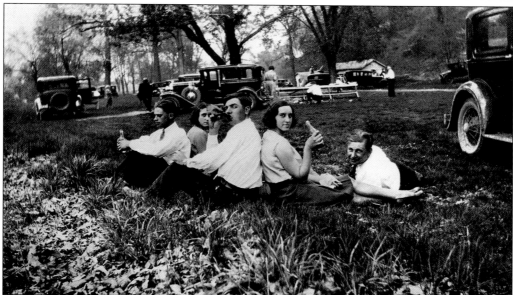

PICNICS. Parks were a good place to hang out with friends and enjoy a swig of soda. Cream soda, grape, root beer, cherry soda, Pepsi-Cola, Coca-Cola—all came in actual glass bottles and cost just a nickel.

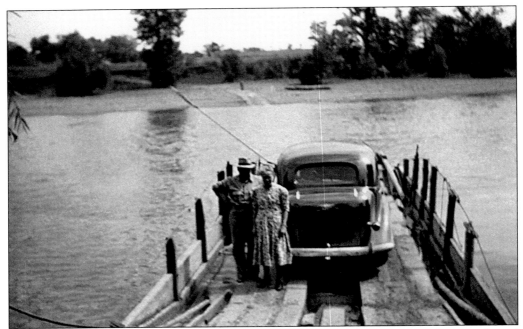

FERRYBOATS. People, supplies, materials, horses, carriages, and, later, automobiles were ferried across the river between Nauvoo and Montrose. This 1940s photograph supplied by Lloyd Starr shows a ferry crossing another river. Note that it is towed from one side to the other by a rope or cable.

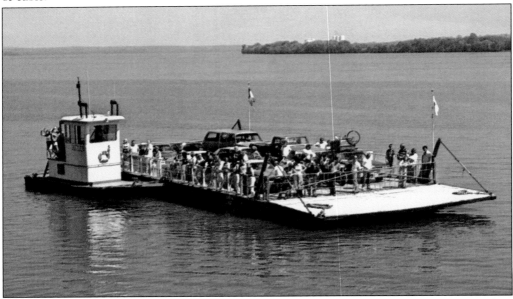

MULTIPURPOSE FERRIES. This bargelike ferry was put into service in 1979 and could haul up to nine cars and 65 people at a time. It operated for only a year or two between Nauvoo and Montrose. Leonard Hogan remembers the time his brother bought a combine in Iowa. He had it brought across the Mississippi by ferry. That was much easier and quicker than coping with bridges, roads, and utility lines.

Eight
WEDDING OF THE WINE AND CHEESE

The years 1937 and 1938 became landmark years, a time of some important events and changes in Nauvoo. Mayor Lowell Horton was a major thrust and a unifying factor behind most of them. Lowell was congenial, a sought-after speaker, an avid promoter of Nauvoo, and untiring in his promotion of tourism. He and a key group of progressive-minded businessmen formed the Unity Club, a forerunner of Nauvoo's chamber of commerce. A new paved river highway was dedicated, and it became a major scenic Illinois attraction. A blue cheese industry was started in 1937, a business that quickly complemented the grape and wine industry, which had already been a mainstay in the community for almost a century. The first annual Nauvoo Grape Festival was held in 1938. The first annual Wedding of the Wine and Cheese pageant was held in 1939 and symbolized the compatibility of Nauvoo's two major industries. These events attracted regional attention and a large attendance each year. The stage was being set for growth, recognition, and a stronger economic base for the town. Tourism expanded. The Mormon Church became interested in Nauvoo and purchased part of the temple site in 1937. Nauvoo was experiencing another metamorphosis.

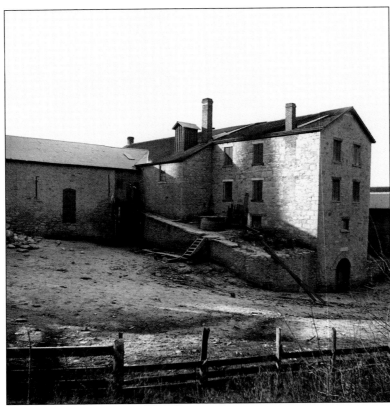

THE OLD BREWERY, 1937. Formerly the Schenks' Brewery (1859–1908), this complex was purchased and converted into a cheese factory to produce the regionally renowned Nauvoo Blue Cheese. (Courtesy Mary Logan.)

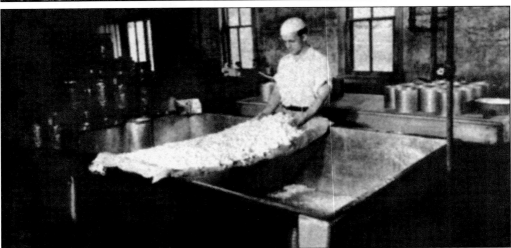

NAUVOO'S BLUE CHEESE INDUSTRY IS BORN. The old limestone cellars in the area were used for curing cheese. Oscar Rhode purchased the old Schenk Brothers' Brewery and enlisted the assistance of Ray Falk, pictured, an expert in the science of cheese making. With the introduction of powdered penicillium roquefortio to the curd, Nauvoo's version of France's famous Roquefort Blue Cheese began production in 1937. Additional buildings were gradually added, and the company employed approximately 80 people in later decades, making it the largest industry in this town of approximately 1,000 citizens.

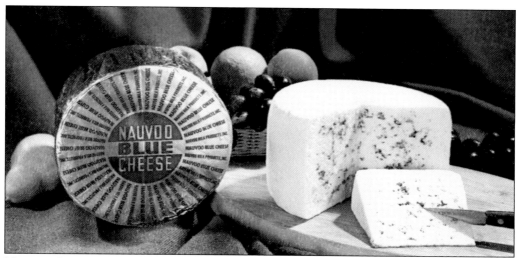

NAUVOO BLUE CHEESE. The tasty cheese shown in this company advertisement became a big factor in Nauvoo's economy for 66 years.

WEDDING OF THE WINE AND CHEESE. The annual pageant (held since 1939) is depicted in this painting by Lane Newberry. (Newberry retired in Nauvoo and painted many of its landmarks.) The bride symbolizes the wine and the groom represents the cheese industry in Nauvoo. According to European legend, long ago a shepherd boy in southern France left his unfinished lunch in a cool limestone cave. Months later, he discovered the bread molded and the curds turned into a blue-veined cheese. He found the cheese tasted delicious, and thus was born the Roquefort cheese industry in France. This process was reinvented in 1937 when local limestone cellars were found ideal for curing a similar cheese in Nauvoo. Grape cutters and milk maids were also key participants in the pageant.

NAUVOO GRAPE FESTIVAL. The first Nauvoo Grape Festival was held in September 1938. Two parades and other activities soon became a part of this annual event. The first Wedding of the Wine and Cheese pageant was initiated in 1939 and incorporated into the grape festival. The three-day celebration developed into a major regional attraction, which was held over September Labor Day weekends. Shown at the left is the 21st annual cover illustrated by Glenn Cuerden. The huge festival and parades resumed after World War II. (A float below shows wine kegs representing the wine industry, and another displays apples and a cider press.)

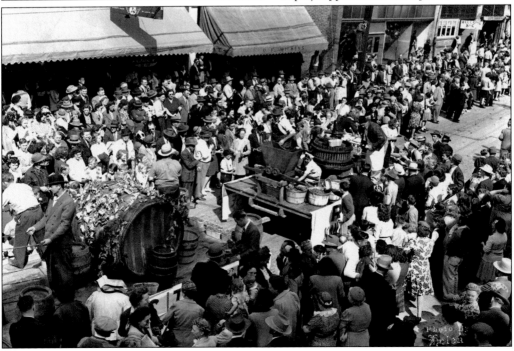

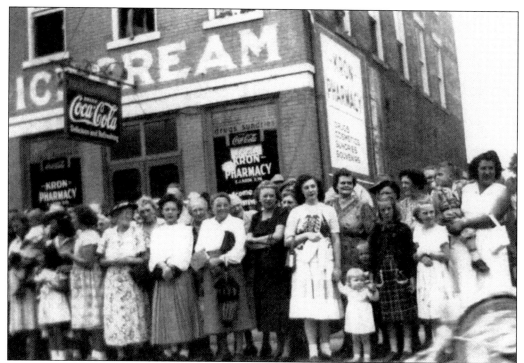

GRAPE FESTIVAL PARADES. The Sunday parade in 1966 attracted an estimated crowd of 80,000, the largest to that date. Saturday's pet parade and the crowning of the queen drew an estimated 15,000 people. The pageant sold over 3,000 tickets. People traveled from surrounding counties for the event. The photograph above shows local spectators in the early 1950s. The Budweiser Clydesdales appeared in two parades around 1962–1963, as seen below.

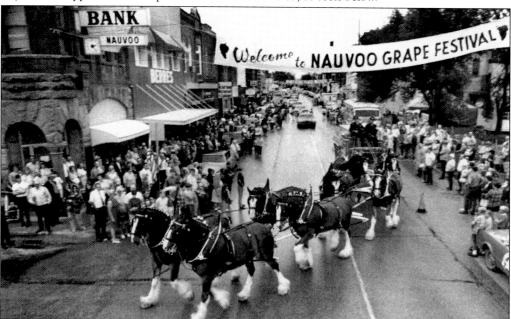

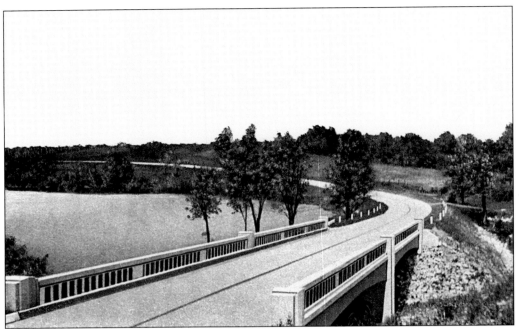

A NEW ROAD, 1937. A new, paved, scenic river road (Highway 96) between Nauvoo and Hamilton was dedicated on October 17, 1937, fulfilling a dream that Nauvoo initiated in 1922. Illinois's Governor Stratton attended the ceremony. The new highway cost $825,000 and boasted 65 picnic tables along the 12-mile route.

THE RIVER ROAD. This stretch of the unpaved road is shown as it appeared at Mount Mariah around 1924. (Courtesy the Nauvoo Historical Society.)

AFTER THE WAR. World War II meant ration books and tokens, and it limited the purchase of goods such as tires, gasoline, and sugar. According to local newspapers, 1946 was the year of the worst flood in the area's history. Nearby Niota was badly damaged—again. After the war, John Kraus bought buildings and started to renovate them, helping to invigorate Nauvoo's run-down business district. This Kraus cafeteria building (above), built in 1918, was gradually expanded as pictured in 1937. The restaurant was one of Kraus's ongoing endeavors, and a theater was added in 1951. (Courtesy Marilyn Kraus.)

NAUVOO STATE PARK. Lowell Horton was instrumental in forming the new Nauvoo State Park. Pictured from left to right at the 1950 dedication are Mayor Horton, Chief Edward Davenport of the Sac and Fox Indian tribe, and Illinois governor Adlai Stevenson.

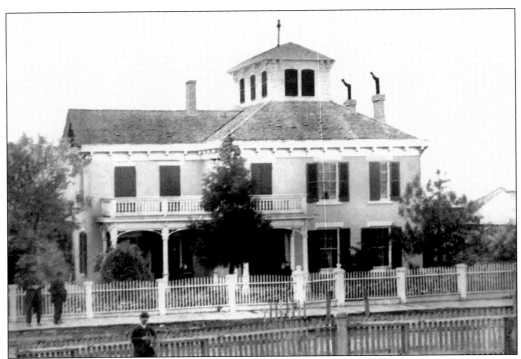

ORIENTAL HOTEL. The original, elegant 1840 Mormon residence of Adam Swartz was purchased by William Reimbold in 1885 and converted to the Oriental Hotel for overnight travelers. In a state of disrepair, it was purchased in 1946 by John Kraus and restored as the Hotel Nauvoo.

HOTEL NAUVOO. One of the most elegant, original buildings in Nauvoo, the hotel is operated to the present day as a very popular dining establishment, drawing repeat customers from a 75-mile radius. (© 2002 photograph by Glenn Cuerden.)

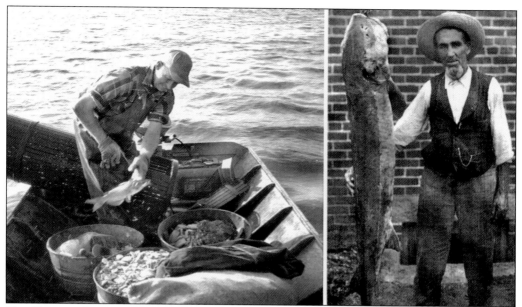

THE FISHING INDUSTRY. In the 1830s, fish were abundant. There were catfish, sturgeon, carp, bass, pike, perch, sauger, muskellunge, and others. They could be huge. This Larry Worrell family photograph (right) displays a 65-pound sturgeon caught upriver near Dallas City by Jack Roe in 1910. Gerald Knipe, pictured on the left in 1964, was one of the area's commercial fishermen from the 1920s until the industry was greatly curtailed in the early 1960s by restrictive EPA standards and commercial fisheries. Depending on the season, Knipe used trotlines, nets, and baskets to catch his fish. (Above left, courtesy Mickey Knipe.)

THE RED FRONT. This had been a hangout for decades on both sides of the 1950s. Farmers came into town on a Saturday night to play cards in the back room, drink Budweisers, cuss, and gossip about the latest goings-on. The lady folks stayed home. In later years, Dottie took over management. It is still a popular hangout, like Grandpa John's down the street, but now, both are basically restaurants. One must try one of Dottie's tenderloins. Of course, both are *the* places to go if one wants to catch up on local gossip. (© 2004 photograph by Glenn Cuerden.)

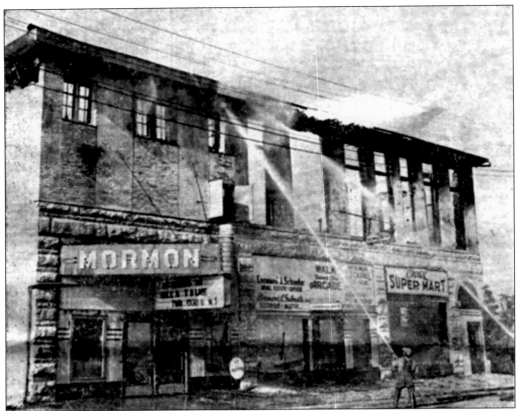

A LANDMARK BURNS, 1949. The landmark Ochsner/Schrader building burned in Nauvoo. It contained the Mormon Theatre and other businesses of owner Leonard J. Schrader. This was the most important major fire since the temple was burned in 1848. (Courtesy the Burlington Hawk-Eye Gazette.)

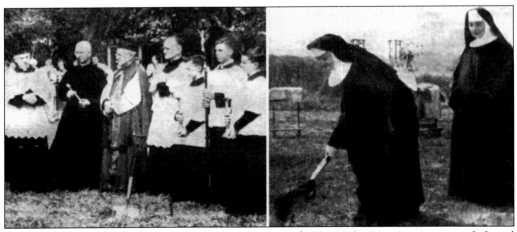

A NEW CONVENT, 1953. Ground is broken for a new $800,000 St. Mary's convent and chapel built by the Benedictine Sisters in Nauvoo. Msgr. Christian Labonte is third from the left in the left photograph.

PURCHASES. During the 1960s, the Mormon acquired properties including this SS. Peter and Paul school on Temple Square. It was purchased in 1961 and torn down in 1972.

RESTORATION, 1962. The Church of Jesus Christ of Latter-day Saints in Salt Lake City began a large-scale acquisition and restoration of former Mormon properties in Nauvoo. On July 27, 1962, Nauvoo Restoration was incorporated in Illinois by the church as a not-for-profit corporation. One of its goals was "to acquire, restore, protect and preserve, for the education and benefit of its members and the public, all or a part of the old city of Nauvoo in Illinois and the surrounding area." An early project (shown above) is this Jonathan Browning home. Browning was the inventor of various repeating rifles. (Photograph by archaeologist Dale Berge.)

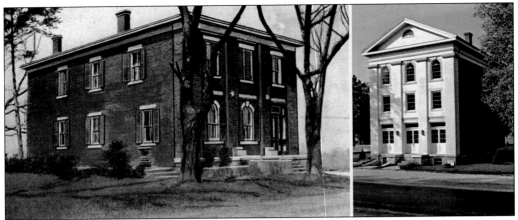

THE OLD MASONIC HALL. By mid-1963 (one year after Nauvoo Restoration's incorporation), the *Salt Lake City Desert News* announced that the organization had acquired 30 of the 35 old Mormon homes still standing in Nauvoo, most awaiting restoration. One such building, the Masonic hall, was constructed in 1844–1845 to meet various needs and to serve Nauvoo's Masonic branch with a third-floor lodge room. A part of the Mormon population was Masons. The first floor contained a theater. The mayor's office and the Nauvoo Legion Armory were on the second floor. The left photograph above shows the building sometime after the third floor was removed in 1884. The version on the right is after the 1978 restoration and the building's name was changed to the Cultural Hall. (Both photographs are from old postcards.)

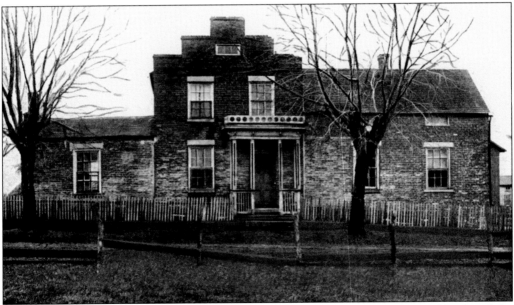

BRIGHAM YOUNG RESIDENCE. This 1843–1846 home of Brigham Young (second leader of the church) was sold for $600 in 1846 as the Mormons were leaving Nauvoo. Repurchased by the church in 1962, it was one of the focal points of the restoration. In the rear, there was a well and a root cellar for storing vegetables.

GIRLS' ACADEMY, 1967. The St. Mary's Academy for Girls was expanded on the crest of the hill overlooking the Mississippi River. It was attended by young women from 48 states and seven foreign countries. This aerial photograph in the October 11, 1998, *Catholic Post*, newspaper of the Diocese of Peoria, shows how it appeared when sold that year.

WATER TOWER. A modern, 80-foot-high water tower was built in 1969. It resembled a large globe positioned on a single base and held 200,000 gallons of water. It was 20 feet higher than the old tower. (Right, © 2006 photograph by Glenn Cuerden.)

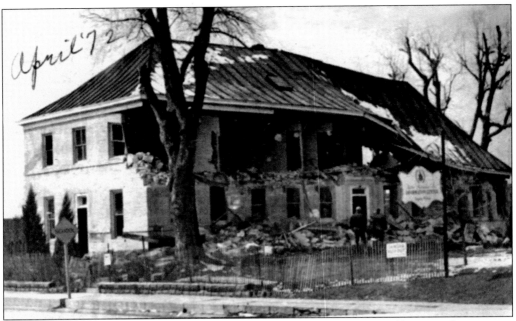

ICARIAN LANDMARK DISAPPEARS. In 1972, this 121-year-old stone building, used at various times by the Icarians, the Catholics, the city, the Mormons, and for private purposes, on the southwest corner of Temple Square was torn down to accommodate the church's upcoming plans. It had served many functions.

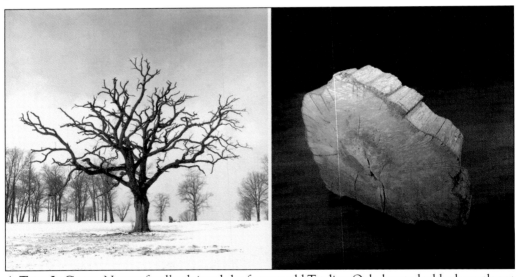

A TREE IS GONE. Nature finally claimed the famous old Trading Oak, located a block southeast of Capt. James White's original homestead near the old ferry landing at the end of Parley Street. The long-dead tree blew down during a storm around 1974. Local myth has maintained that Captain White purchased his land from the American Indians under this large burr oak. However, a count of the rings indicates it was perhaps a sapling in White's time and, if so, too young to logically have played a role in that historical event. (Left, © 1973 photograph by Glenn Cuerden; right, © 2005 photograph by Glenn Cuerden, courtesy the Weld House Museum.)

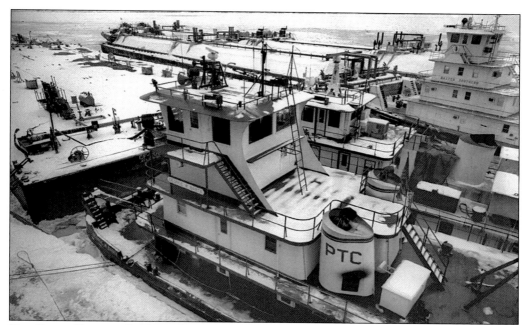

THE RIVER FREEZES. In December 1983, over 80 barges were stranded in the Nauvoo area after a sudden freeze. They waited for a February thaw before they could be broken free. Locals say the towboats were lit up at night, and it seemed as if there were a whole city out on the ice. (© 1983 photograph by Glenn Cuerden.)

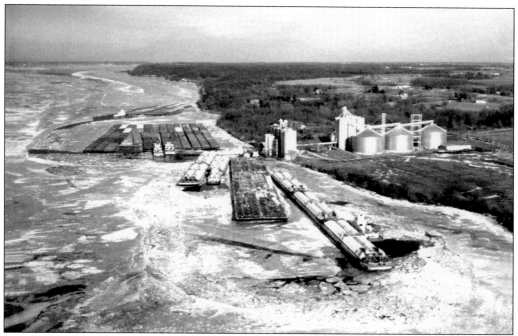

ICEBOUND. These barges at the elevator were not able to leave for months. The towboats ran their engines periodically to keep from getting icebound and crushed. This photograph is from an unknown newspaper.

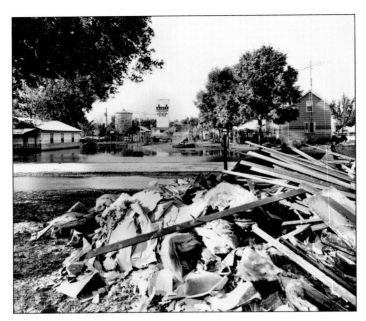

FLOODS, 1993. The Mississippi River flooded many towns along its banks. The whole town of Niota (upriver from Nauvoo) was partially submerged in muddy water for days, as seen by the waterline on these buildings. Downriver in Warsaw, some buildings were also partially submerged. Due to its location on the river, Nauvoo never experienced a serious flooding problem except in 1844 when the lowest area of the Flat was flooded. This picture was taken during Niota's cleanup stage after most of the water had receded. (© 1993 photograph by Glenn Cuerden.)

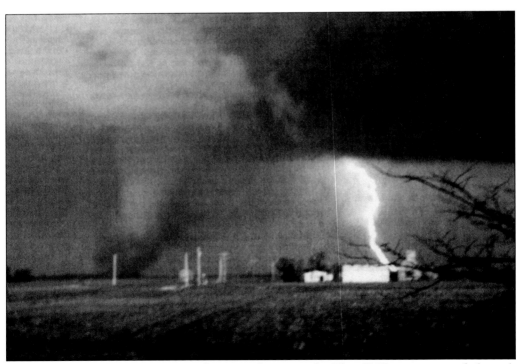

TORNADOS. The disasters continued at periodic intervals. This 1995 twister ripped through Hancock County, damaging 55 buildings. It demolished the stone Tull Schoolhouse near Pontoosuc, one of many country schools that once dotted the rural countryside every two miles. Scott Hallowell captured this scene near LaHarpe in Hancock County.

Nine
The Mormons Return

The Mormon Church had been purchasing and restoring properties since approximately 1960. A 1999 announcement of plans to reconstruct a new temple, a close replica of its predecessor, suddenly ushered in a new era, and it sparked growing concerns among Nauvoo locals. Many longtime citizens and merchants pondered the impact on the town—and their own fate. Like residents of most small communities, they liked the status quo, they were comfortable with it, and were basically resistant to dramatic change. The announcement to rebuild the Mormon temple signaled the need for major change in the town's infrastructure. The Mormons' Utah headquarters and the City of Nauvoo worked together to coordinate the 2002 completion.

The Mormons, in 1999, owned approximately 50 percent of the property in Nauvoo. In 2006, the population of Nauvoo remains at approximately 1,000 people. It has hovered there for many decades. That is what most locals like about this quiet farming community with its seven churches.

Time has its own way of precipitating change, even though it may not have seemed so to Nauvoo citizens during the mid-1900s. Landmarks have fallen through the years: the first temple, Capt. James White's home, all Icarian buildings, the Opera House, the Ochsner/Schrader building, Parish Hall, the Mormon Arsenal building, the Parochial School, the old oak tree, Spalding/St. Edmund's/Benet Hall, the RLDS Church, St. Mary's Academy, the Nauvoo Blue Cheese Factory, and over a century of personal family homesteads. Nauvoo is visually disappearing before its residents' very eyes. And everyone seems to have completely forgotten the 1803 frontier cabin of William Ewing and the 1820s lodge encampment of Chief Quashquame.

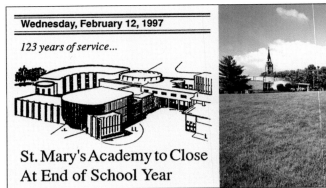

GIRLS' ACADEMY CLOSES. The academy shut its doors in 1997 due to dwindling enrollment. In 1998, the Benedictine Sisters accepted an offer to sell most of their 23 acres to the Mormon Church, headquartered in Salt Lake City. The Benedictines decided to relocate to Rock Island. In 1999, the Mormon Church announced plans to rebuild the Nauvoo Temple on the original temple site. Groundbreaking began the same year. Part of the St. Mary's Academy buildings on the Hill were removed, leaving a large open expanse between the temple and the river, as seen above. (© 2002 photograph by Glenn Cuerden.)

TOURS ON THE FLATS. By now, the Utah Mormon Church and the RLDS (renamed the Community of Christ Church, which owns Joseph Smith landmarks) have developed the Nauvoo Flats into a well-groomed mini-Williamsburg. The area is immaculately landscaped with beautiful flowers, gardens, planted trees, and painted fences. There are horse-drawn wagon tours, living history reenactments, activities, craft demonstrations, statues, and tourist centers, all promoting the Mormon religion. Nauvoo attracts 100,000 to 150,000 visitors a year. Dozens of restored homes and workshops emulate ideal conditions in the original Mormon era, and all are open free for tours. May through October, Mormons and non-Mormon tourists from around the world are attracted to this scenic restoration, including these visitors from Elysian. (© 2005 photograph by Glenn Cuerden.)

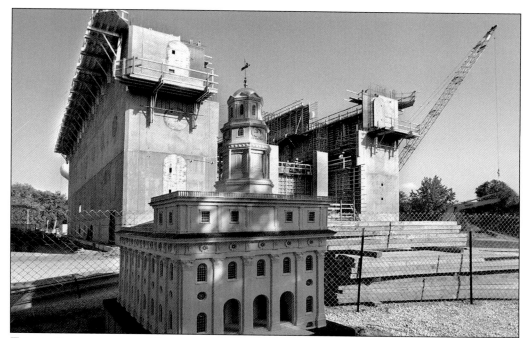

TEMPLE CONSTRUCTION. The new temple was completed on the crest of the Hill, patterned after the original on the same Temple Square location as seen by the scale model in the foreground. In 2002, as the sky turns dramatic, the statue of Moroni is hoisted into position atop the temple during a special September 21 ceremony. (Above, © September 2000 photograph by Glenn Cuerden; below, photograph © Mary Logan.)

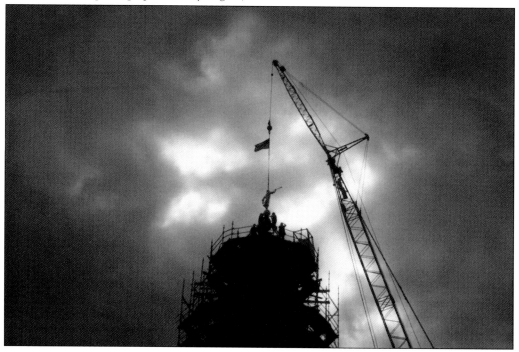

HOUSING, 2001. Many apartment buildings are being constructed by the church as temporary residences on the Flats for the missionary guides and caretakers who stay in Nauvoo during the summer season. The design follows the basic style of the original Mormon brick homes. (© 2001 photograph by Glenn Cuerden.)

NAUVOO'S BUSINESS DISTRICT. A quiet summer Sunday afternoon is depicted in this 2002 photograph. There are few people uptown as the tourist season draws to a close. (© 2002 photograph by Glenn Cuerden.)

TEMPLE COMPLETION, 2002. Celebrated with a seven-week open house, the completed temple attracted approximately 200,000 visitors. Most were Mormon, and they systematically arrived in tour buses. This was a major event for the little town and required extensive preparation. Tourists, locals, and the media, as well as Mormons, were invited to take tours before the official dedication. (© 2002 photograph by Glenn Cuerden.)

NEWS MEDIA GATHER. This interview was conducted by Iowa Public Television before the May 6–June 22 open house. The temple was officially dedicated on June 27, 2002. (© April 30, 2002 photograph by Glenn Cuerden.)

NAUVOO'S CHURCHES. The Nauvoo community has boasted seven churches for a long time, and they work in harmony. The Christ Lutheran Church (pictured) is one of the oldest. It was organized as the German Evangelical Church of Nauvoo in 1851. There is also the First Presbyterian Church and the United Methodist Church. The Community of Christ, Nauvoo Baptist, and the Mormon Church of Jesus Christ of Latter-day Saints (in addition to the Mormon temple) are all relatively new structures. The Catholic church (the oldest) now retains only the property adjacent to the Mormon temple block, which contains the SS. Peter and Paul Church, the rectory, the Catholic Primary School with its adjacent parking, and the Villa Marie, which was the original Irish St. Patrick's Church. The Appanoose Faith Presbyterian is a short distance from Nauvoo. Some of the oldest churches were originally German; the First German Methodist Church was organized in 1846, and the German Presbyterian was formed in 1869. (© 2005 photograph by Glenn Cuerden.)

CHEESE FACTORY SOLD. The Nauvoo Blue Cheese factory, the buildings, equipment, and its famous name, were sold in 2003 by Con Agra (its last owner) to Saputo, a Canadian firm. Saputo immediately closed the doors after 66 years of operation (1937–2003). This abrupt closure left many local citizens pondering the recent drastic changes in Nauvoo and the consequences of losing a substantial local tax base, which the factory had provided. The cheese factory was the major industry in Nauvoo, hiring as many as 80 people during one period. The 64-year-old annual Wedding of the Wine and Cheese pageant was temporarily discontinued. What good is a wedding with one partner missing? It was later reinstated. (© 2003 photograph by Glenn Cuerden.)

BEFORE AND AFTER. The Mormon Church purchased the abandoned cheese factory from Saputo in 2005. Everything was torn down the same year, and nothing remained of this major Nauvoo industry—not the original portion, which started out as the Schenks' Brewery, not the buildings, which became the cheese factory in 1937, and not the more recent additions. Just a grassy field and one small stone summer kitchen remained. (© 2005 photographs by Glenn Cuerden.)

MAJOR NEW DEVELOPMENTS. Another landmark on Mulholland Street changes. In late 2005, this home's distinctive Victorian porch (above) was stripped, and the building was renovated (below). It was originally the home and boot shop of Charles Hales and much later became the Sanders Antique Shop. It is now envisioned as part of a "village," including eight two-story buildings (condominiums or units) on a block-square development. The large units can be rented by groups, by the day or by the week. (Above, © 2002 photograph by Glenn Cuerden; below, © 2005 photograph by Glenn Cuerden.)

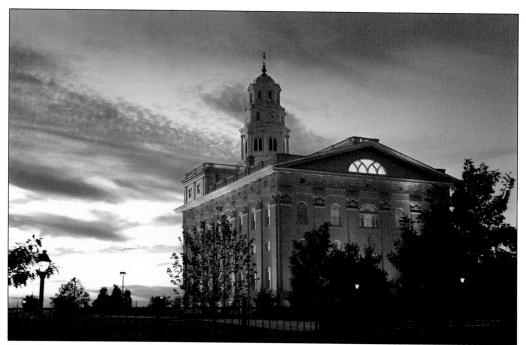

THE COMMUNITY. To date, there are very few permanent Mormon residents in Nauvoo. Most come to serve a term of church duty, and they operate the historic sites or serve other functions for the church during the summer months. Other Mormons are gradually moving to Nauvoo to retire or to operate their own tourist-related businesses. (© 2005 photograph by Glenn Cuerden.)

APRIL 2006. Another huge project is under development at the curve on the east edge of town. According to rumors among nervous locals, it is said to be planned as a motel, or a multiuse mini-mall, including units for small retail stores on approximately one square block of property. Some "vandal" has added his own editorial sign to the site. This site is only one of about six new projects under construction, and a massive phase of construction by various private entities is now in progress. (© 2006 photograph by Glenn Cuerden.)

LOOKING BACK. Glancing south toward town from the North Hill, one can occasionally see two tall steeples above the treetops. Upon reflection, the first decade of 2000 appears almost a déjà vu of Nauvoo's 1839–1846 era, but in a drastically different time, and most certainly with a far different outcome. What exactly that will be, one can only guess. (© 2004 photograph by Glenn Cuerden.)

MAY 2006. The Hotel Nauvoo Restaurant still attracts locals from a 75-mile radius as well as serving a robust tourist trade. The Nauvoo State Bank, founded in 1893, is within a block of its initial location. The sixth-generation Baxter Winery is the longest-running business in Nauvoo. Verona Kraft's Market has been a landmark at the edge of town since 1960. Many longtime businesses (and residents, a few in their mid-90s) are still very active. What is going to happen next to this historic little riverside community and its local citizens who have savored a long heritage and have (themselves) carved out a century and a half of their own accumulated history? (© 2006 photograph by Glenn Cuerden.)

BIBLIOGRAPHY

Much of my information has been gathered from sources listed on page 6. The *Nauvoo Independent* newspaper, published 1873–1973, has served as an invaluable resource. This bibliography is a partial listing of books and periodicals that have also provided important insights and cross-references in my effort to verify facts and resolve conflicting accounts.

Andreas, A. T. *An Illustrated Historical Atlas of Hancock County, Illinois.* Chicago: A. T. Andreas, 1874.
Blum, Ida. *Nauvoo An American Heritage.* Nauvoo, IL: Ida Blum, 1969.
Brodie, Fawn M. *No Man Knows My History: The Life of Joseph Smith, the Mormon Prophet.* New York: Vintage Books, 1995.
Burlington Hawk-Eye Gazette. Burlington, IA.
Carthage Republican. Carthage, IL.
Daily Gate City. Keokuk, IA.
Dallas City Enterprise. Dallas City, IL.
Ford, Thomas. *A History of Illinois.* Chicago: S. C. Griggs & Co., 1854.
Fort Madison Democrat. Fort Madison, IA.
Gibbons, Ted. *The Road to Carthage.* Provo, UT: Maasai, Inc., 2001.
Givens, George, and Sylvia Givens. *Nauvoo Fact Book.* Lynchburg, VA: Parley Street Publishers, 2000.
Givens, George W. *In Old Nauvoo.* Salt Lake City, UT: Deseret Book Co., 1990.
Gregg, Thomas. *History of Hancock County, Illinois.* Chicago: Chas. C. Chapman & Co., 1880.
Hamilton Pilot. Hamilton, IL.
Hamilton Press. Hamilton, IL.
Hancock County Journal. Carthage, IL.
Hancock County Journal-Pilot. Dallas City, IL.
Johansen, Jerald R. *After the Martyrdom.* Bountiful, UT: Horizon Publishers & Distributors, 1997.
Hallwas, John E., and Roger D. Launius. *Cultures in Conflict.* Logan: Utah State Univ. Press, 1995.
Hancock County Historical Society. *Historic Sites and Structures of Hancock County, Illinois.* Carthage, IL: Hancock County Historical Society and the County Bicentennial Commission, 1979.
Hancock County Supervisors. *History of Hancock County, Illinois.* Hancock County, IL, 1968.
Mccomb Daily Journal. Mccomb, IL.
Miller, David E., and Della S. Miller. *Nauvoo: The City of Joseph.* Utah History Atlas, 2001.
Nauvoo Grapevine. Nauvoo, IL
Nauvoo Independent. Nauvoo, IL.
Nauvoo New Independent. Nauvoo, IL.
Nauvoo Neighbor. Nauvoo, IL.
Oaks, Dallin H., and Marvin S. Hill. *Carthage Conspiracy.* Urbana, Univ. of Illinois Press, 1979.
Quincy Herald-Whig. Quincy, IL.
Smith, Joseph III. *The Memoirs of President Joseph Smith III (1832–1914).* Edited by Mary Audentia Smith Anderson. Independence, MO: Price Publishing Co., 2001.
Sutton, Robert P. *Les Icariens.* Urbana: Univ. of Illinois Press, 1994.
Swinton, William. *Condensed U.S. History.* New York: Ivison, Blakeman, Taylor & Co., 1879.
Temple, Wayne C. *Indian Villages of the Illinois Country.* Springfield, IL: Illinois State Museum, 1977.
Times and Seasons. Mormon publication. Nauvoo, IL, 1839–1846.

Discover Thousands of Local History Books Featuring Millions of Vintage Images

Arcadia Publishing, the leading local history publisher in the United States, is committed to making history accessible and meaningful through publishing books that celebrate and preserve the heritage of America's people and places.

Find more books like this at
www.arcadiapublishing.com

Search for your hometown history, your old stomping grounds, and even your favorite sports team.

Consistent with our mission to preserve history on a local level, this book was printed in South Carolina on American-made paper and manufactured entirely in the United States. Products carrying the accredited Forest Stewardship Council (FSC) label are printed on 100 percent FSC-certified paper.